Illuminati

In the Music Industry

Illuminati

In the Music Industry

Mark Dice

The Resistance
San Diego, CA

Illuminati in the Music Industry
© 2013 by Mark Dice
All Rights Reserved
Published by The Resistance
San Diego, CA

Printed in the United States of America

First edition printed in November 2013

Visit www.MarkDice.com

ISBN: 978-09887268-1-9

Table of Contents

About the Author

Mark Dice is a media analyst, political activist, and author who, in an entertaining and educational way, gets people to question our celebrity obsessed culture, and the role the mainstream media and elite secret societies play in shaping our lives.

He frequently stirs up controversy from his commentaries, protests, and boycotts, and has repeatedly been featured in major media outlets around the world. Mark's YouTube channel has received tens of millions of views and his viral videos have been mentioned on the Drudge Report, ABC's The View, Fox News, CNN, TMZ, the Washington Times, New York Post, USA Today, and many more.

Mark has been featured on the History Channel's *Decoded, Conspiracy Theory with Jesse Ventura,* E! Channel's *Secret Societies of Hollywood,* Alex Jones' *9/11 Chronicles,* and has attended protests against the Bilderberg Group, the Bohemian Grove, and the Federal Reserve Bank in Washington D.C.

Mark has written several popular books on secret societies and conspiracies, including *The Illuminati: Facts & Fiction, The New World Order: Facts & Fiction,* and *Big Brother: The Orwellian Nightmare Come True.* While much of Mark's work confirms the existence and continued operation of the Illuminati today, he is also dedicated to debunking conspiracy theories and hoaxes and separating the facts from the fiction; hence, the "Facts & Fiction" subtitle for several of his books.

He has a bachelor's degree in communication from California State University.

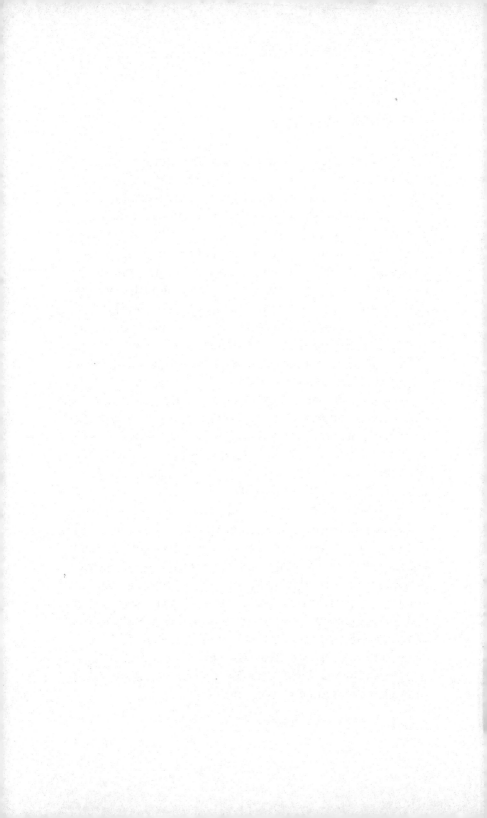

Introduction

Practically everyone has seen or heard of the satanic symbolism used by rock and heavy metal bands, particularly dating back to the 1980s when Ozzy Osbourne, Motley Crue, and many others incorporated satanic pentagrams, images of devils, and even dramatized human sacrifices into their performances and lyrics. But after a while the whole "satanic shock rock" fad faded into the past with most musicians eventually abandoning satanic imagery and themes. This was not the end of the story though, because accusations of satanism and secret messages would resurface again in the 21st century, and weren't just limited to heavy metal or rock bands. Blatant Satanic symbolism made a strong comeback, this time, in rap and hip hop, and also in many seemingly family friendly teen idols, including female pop stars who are household names.

It's not just any kind of Satanism that's said to have been adopted by these pop stars—its Illuminati symbolism—from the infamous secret society talked about in many conspiracy circles. This "Illuminati" is said to be the puppet masters—the Invisible Empire believed by many—who follow conspiracy theories—to control the world. Yes, that infamous superclass secret society of billionaires, media moguls, European royalty, and elite politicians. Famous pop stars and rappers from Jay-Z and Rick Ross, to Rihanna and Christina Aguilera are said by many to be "satanic" or "Illuminati" and allegedly use Illuminati symbolism in their music videos, on their clothes, and wear Illuminati jewelry that goes unnoticed by those not "in the know."

1

Since these stars appear in our livings rooms on family friendly mainstream shows like *Good Morning America, Ellen,* and dozens of others—and are loved by virtually all the kids—they couldn't possibly have anything to do with the infamous Illuminati or anything "satanic," could they?

In this book I will show you in shocking detail just how many mainstream musicians with household names and millions of preteen fans are false idols pumping garbage into people's brains while being presented as role models for children to look up to, learn from, and mimic. Many men and women of all ages actually idolize these musicians, and see them as modern day gods and goddesses. No, this is not a "backwards messages made the teens kill themselves," kind of book. We will, however, look at the lyrical and visual content of mainstream, Grammy Award winning artists, whose songs are played on radio stations around the world, and we will analyze the various effects consuming such content on a regular basis has on listeners' beliefs and behavior.

Aside from mainstream musicians being human products designed and manufactured by record companies that know how to mass produce novelty songs about love and relationships, many artists are promoting self-destructive, disempowering and callous materialistic ideas in their lyrical content and accompanying music videos. Exactly what is their purpose? What is this "Illuminati symbolism" people are talking about? Are some musicians really "in" the Illuminati secret society?

Living in the information age and because of various major world changing events appearing to unfold as if there's a hidden hand pulling the strings, more and more people are stumbling across, or somehow finding the

"Illuminati rabbit hole" through events like the September 11th attacks, the global economic collapse, or the ever-increasing Big Brother Orwellian surveillance society we are living in. A growing number of people are beginning to believe that the Illuminati are secretly in control of the government, banks, the mainstream media, and major world events. While many people are obviously disturbed by the idea that a powerful mystical secret society could be operating as a shadow government manipulating our planet, others, however, see the Illuminati not as a threat to our freedoms, our well-being, or the economy, but instead look up to them and see the Illuminati's immense perceived power appealing just as countless people are drawn to gangster films and often fantasize about working for the Italian mafia because of the power certain mafia men wield.

Since the Illuminati mafia is considered to be the most powerful organization in the world, eclipsing by far the Italian mob, and as more and more people have learned about the Illuminati or heard about "Illuminati conspiracy theories," an increasing number of people began to look up to them as "cool," and the ultimate gangsters.

Many rap artists, as you know, not only portray characters who are gangsters, but some even use stage names taken from famous (real) gangsters or drug dealers, and in their songs and videos they brag about killing people, making tons of money, and sleeping with all kinds of women. More recently we've seen the emergence of artists incorporating Illuminati themes into their songs, dress, and music videos, so throughout this book we will look at the emergence of Illuminati symbolism and lyrical content in mainstream music today, as well as the psychological and social effects of simply listening to

music. Many still deny that listening to music can have any ill effect on people, let alone society, but we'll take a look at what famous musicians and media moguls have to say about the subject, as well as some very serious scientific studies into the matter.

There is always the issue of parental control to manage the content children are exposed to, but as you know, most artists are falsely advertised as child-friendly, or later change their image and message to something more hardcore after they have achieved mainstream success with a chart-topping album or two. Many of the artists in this book you may be familiar with, or even a fan of. You've probably heard their songs hundreds and hundreds of times, but you're about to take a close and revealing look at them, and I'm sure you'll never see them the same way ever again.

Of course most artists don't write their own songs and they are just actors, essentially, performing songs their studios purchased with the goal of entertaining the audience with lyrical content that would resonate with the masses. The 1990s duo Milli Vanilli is a classic example showing how artists are often assembled and created by studios, not organically developed by a group of talented kids who are friends and passionate about singing, but instead by industry professionals who know how to create carefully crafted superstars who are then sold around the world.

Lou Pearlman, for example, created various super successful boy bands like 'N Sync and the Backstreet Boys, and was later sent to prison after being convicted of fraud for scamming people out of an estimated $300

million dollars.[1] The man had no experience in the music industry, but because of his slick, con artist mind, was able to build those various boy bands and launch them to stardom.

It's important to note that the music industry financially supports artists whose music preaches socially destructive messages, and builds them up as role models who the brain-dead mainstream music loving mentally enslaved masses worship as idols. The fact that many musicians achieve massive success isn't necessarily because they are extremely talented—instead, it's a result of being chosen by a record label to be promoted because their songs encourage violent, immoral, and social destructive behavior. Their music is literally used to brainwash the listeners through social conditioning. I'm not saying all successful mainstream artists are bad, but a shockingly large number of them are simply pure trash.

Occasionally an artist who is an Illuminati pawn will actually produce a song which counters their very purpose for being promoted, as in the case of Eminem's 2004 hit *Mosh*, a blistering attack against George W. Bush and the War in Iraq. But in most cases such songs are overwhelmingly overshadowed and drown out by the extraordinary amount of content designed to destroy the listener's mind.

The Illuminati symbolism in music videos has gotten so blatant in recent years that even some mainstream news outlets have reported on the rumors and allegations surrounding various artists. In previous years, Illuminati conspiracy theories had sparked bestselling books like Dan Brown's *Angels and Demons*,

[1] *Associated Press* "Boy band founder to plead guilty in $300M suit" (March 4[th] 2008)

and even some popular films like *Tomb Raider*, starring Angelina Jolie, where the plot revolves around her battling against the Illuminati as they seek a device that will give them ultimate power. More recently the Puma clothing company has released an Illuminati themed clothing line titled "Shadow Society" featuring pyramids and sun symbols, two of the most popular Illuminati images, and rappers like Kanye West and even sports figures like LeBran James have been photographed wearing clothes featuring obvious Illuminati symbolism.

Some people believe the reason this symbolism has become so blatant is because the Illuminati themselves are partaking in the "revelation of the method" and openly displaying their power on purpose to brag about it as they are preparing to allegedly "externalize the hierarchy" and finally announce their presence to the world as the supposed divine custodians of the "royal secret" who are preparing the planet for the arrival of the messiah (or more accurately, the antichrist).

Others see this as a way to muddy the water around the Illuminati in order to cover up for their political and banking activities by flooding society with disinformation in order to convince people that the Illuminati is just some kind of fictional myth involving rappers and pop stars, so the real Illuminati can continue to operate without disruption or people seriously investigating their existence and activities.

The Illuminati have even been accused of murdering many famous musicians, including Michael Jackson, Tupac, Whitney Houston, and others, by fans who say they were killed because they wouldn't go along with the industry's agenda or as a sacrifice to Satan for the final payment of their fame. While many of these allegations may be farfetched and unfounded, it is

undeniable that a large number of industry elites have aligned themselves with this superclass cabal.

In the past, a small number of musicians have occasionally referenced the Illuminati in their songs hoping to warn people about their evil activities, although most of these artists are underground and are rarely, if ever, played on the corporate owned airwaves controlled by Clear Channel or similar monopolized markets. Some of these independent artists, such as Immortal Technique and Prodigy, have mentioned the Illuminati by name, while other rappers and rockers seem to be very well aware of the evil deeds of the brotherhood, a fact that becomes clear by simply listening to the lyrics of their songs or watching the music videos that accompany them.

But these independent artists who have warned about the Illuminati or who have tried to expose them, are vastly outnumbered by the growing list of mainstream artists who have openly, or subtly, embraced the Illuminati secret society as something they want their listeners to believe they are a part of, or affiliated with, in some way. And as I said before, most of these artists are pure trash, or what I call "satanic scumbags" and part of the mainstream (urine stream) music business.

Even thousands of years ago, philosophers like Plato, Aristotle, and Socrates understood the tremendous influence music has on its listeners. Aristotle recognized that music communicates emotion and can even shape people's character, warning, "If one listens to the wrong kind of music, he will become the wrong kind of person."

Plato said that music was once pure and conveyed only positive thoughts and emotions in the listeners, but later, "an unmusical anarchy was led by poets," who

promoted "promiscuous cleverness and a spirit of law-breaking."[2]

Plato also wrote that, "They were men of genius, but they had no perception of what was just and lawful in music...And by composing licentious works [lacking legal or moral restraints]" they "have inspired the multitude with lawlessness and boldness."[3]

Socrates, another major figure in ancient Greek philosophy, said, "Musical training is a more potent instrument than any other, because rhythm and harmony find their way into the inward places of the soul, on which they mightily fasten, imparting grace, and making the soul of him who is rightly educated graceful, or of him who is ill-educated ungraceful."[4]

Christian philosopher Boethuis said in the sixth century that, "Music is part of us, and either ennobles or degrades our behavior."[5]

The ancient Chinese philosophy text, the *Shu Ching*, reads "for changing people's manners and altering their customs there is nothing better than music."[6]

Marilyn Manson, the satanic shock rocker from the 1990s stated that, "Music is the strongest form of magic."[7] As you know, music and music videos go hand in hand. Joseph Goebbels, the infamous Nazi propagandist and member of Adolf Hitler's inner circle, said that motion pictures were, "one of the most modern

[2] Plato, *Laws* 700-701a. cited in Wellesz, p. 395
[3] Plato Laws III 700-701, from Great Books volume 7: 675-676.
[4] Benjamin Jowett (trans.), The Republic of Plato (Oxford Clarendon Press, 1888): 88.
[5] BrainyQuote.com
[6] Quoted in Shapiro, *An Encyclopedia of Quotations about Music* (1978)
[7] BrainyQuote.com

means of mass persuasion," and "film was one of the most modern and far reaching means for influencing the public that has ever existed."[8]

Ted Turner, the man who founded CNN, the first 24-hour cable news network, stated, "You know that everything we're are exposed to, influences us...those violent films influence us, and the TV programs we see influence us. The weaker your family is, the more they influence you. The problems with families in our societies are catastrophic, but when you put violent programs before people who haven't had a lot of love in their lives, who are angry anyway, it is like pouring gasoline on the fire."[9]

David Puttnam, former Chairman of Columbia Pictures, and Academy Award winning producer of *Chariots of Fire* and *The Killing Fields*, said, "Movies are powerful. Good or bad they tinker around inside your brain. They steal up on you in the darkness of the cinema to form or conform social attitudes. They can help to create a healthy, informed, concerned and inquisitive society or, in the alternative, a negative, apathetic, ignorant one."[10]

Former vice president of Disney, Ken Wales, remarked, "As a member of this industry I wish that there were hundreds of stars and writers and directors standing here with me. I suppose they are out protesting toxic waste! Let me tell you there happens to be toxic waste in

[8] Joseph Goebbels speech on February 9, 1934

[9] *Los Angeles Times* "We're Listening, Ted" by Jane Hall (April 03, 1994)

[10] *Los Angeles Times* "Film Makers Are Missing Their Social Purpose" (May 02, 1988)

other areas besides our rivers. That happens in the pollution of our minds, our souls and our spirits!"[11]

Eddy Manson, who was a popular composer for such films as *Born on the Fourth of July* and *Breakfast at Tiffany's*, stated that, "We manipulate people like crazy in films...It's a tremendous release. I can make you feel any emotion I want you to feel at any time. It's a Machiavellian power we project gut to gut."[12]

Gus Van Sant, the Academy Award nominated director of *Goodwill Hunting*, stated, "I believe the properly manipulated image can provoke an audience to the Burroughsian [13] limit of riot, rampant sex, instantaneous death...The raw materials of inspiration include elements as primal and potentially frightening as violence, sex, and death...the primitive world of blood and flame is still with us."[14]

Alan J. Pakula, the director of *All The President's Men*, a film about the Watergate scandal based on the nonfiction book of the same name written by Bob Woodward and Carl Bernstein, admitted, "Movie violence is like eating salt. The more you eat, the more you need to eat to taste it at all. People are becoming immune to the effects: The death counts have quadrupled...they're becoming deaf to it. They've developed insatiability for raw sensation."[15]

Even Oliver Stone admitted, "The cynicism has now gone too far. We are becoming what the history

[11] Cited in *Hollywood vs. America* by Michael Medved page 39

[12] iTunes Biography for Eddy Manson in iTunes Preview

[13] Pertaining to William S. Burroughs (1914–1997), American novelist, poet, essayist and performer, a primary figure of the Beat Generation.

[14] *LA Style* p139 (December 1991)

[15] *Entertainment Weekly* Article by Alan J Pakula page 51 (8/30/90)

books tell us late Rome was like—mired in decadent self-absorption and the lacking virtue."[16]

Anton Lavey, the founder of the Church of Satan and author of *The Satanic Bible*, wrote, "Many of you have already read my writings identifying TV as the new god. There is a little thing I neglected to mention up until now—television is the major mainstream infiltration for the New Satanic religion."[17]

A 1980 study by George Washington University researchers found that Hollywood's producers, writers and directors view themselves as, "crusaders for social reform in America." [18] Lichter, Lichter & Rotman conducted a survey of 240 journalists at major national media outlets such as *The New York Times, Washington Post, Newsweek, Time magazine, U.S. News & World Report, Wall Street Journal*, ABC, CBS, NBC, PBS, etc., and asked them their political attitudes and voting patterns. The report showed that most people at these companies had liberal views and the findings were later published as a book titled *The Media Elite*.

A famous rant about the power of television by the character Howard Beal in the 1976 film *Network* still rings true today, when he shouted, "This tube can make or break presidents, popes, prime ministers...This tube is the most awesome God-damned force in the whole godless world, and woe is us if it ever falls into the hands of the wrong people."[19]

The man credited as the father of public relations

[16] Changall, David - Oliver Stone Stone quoted in *Surviving the Media Jungle* p.141 (1996)
[17] LaVey, Anton - *The Devil's Notebook* page 86
[18] Lichter, Lichter & Rotman Public Opinion 1/83 p55
[19] *Network* (1976) written by Paddy Chayefsky, starring Peter Finch

is Edward Bernays, and early in the twentieth century he was a master of social engineering, propaganda, and shaping public opinion. Bernays was also the nephew of the famous psychologist Sigmund Freud, which may help explain how he became interested in psychology. In 1928 he published a book titled *Propaganda* that described his methods for shaping public opinion and people's attitudes and behaviors through the use of mass media. A quick glance over several excerpts from *Propaganda* reveals just how powerful the control of information is to anyone wanting to influence large numbers of people, or society as a whole.

Bernays wrote, "Those who manipulate the unseen mechanism of society constitute an invisible government which is the true ruling power of our country. We are governed, our minds are molded, our tastes formed, our ideas suggested, largely by men we have never heard of...in almost every act of our lives whether in the sphere of politics or business in our social conduct or our ethical thinking, we are dominated by the relatively small number of persons who understand the mental processes and social patterns of the masses. It is they who pull the wires that control the public mind, who harness old social forces and contrive new ways to bind and guide the world."[20]

He went on to admit, "Whatever of social importance is done today, whether in politics, finance, manufacture, agriculture, charity, education, or other fields, must be done with the help of propaganda. Propaganda is the executive arm of the invisible government."[21]

[20] Bernays, Edward – *Propaganda* page 37-38
[21] Bernays, Edward – *Propaganda* page 47-48

Bernays also revealed, "The invisible government tends to be concentrated in the hands of the few because of the expense of manipulating the social machinery which controls the opinions and habits of the masses."[22]

This is strikingly parallel to what George Orwell said in his classic novel *Nineteen Eighty-Four*, where he wrote, "All the beliefs, habits, tastes, emotions, mental attitudes that characterize our time are really designed to sustain the mystique of the Party and prevent the true nature of present-day society from being perceived."[23]

Edward Bernays can be largely credited with making cigarette smoking popular and appearing cool because in 1929 he was hired by the American Tobacco Company in order to help promote smoking and increase their business. He did this by hiring a group of attractive female models to light up cigarettes while marching in the New York City parade in order to break the taboo of women smoking in public. He coordinated this stunt with a press release saying they lit up "Torches of Freedom" to support women's rights. The following day *The New York Times* ran an article with the headline, "Group of Girls Puff at Cigarettes as a Gesture of Freedom."[24] He really was an evil genius.

Bernays was also the man responsible for diamond rings becoming synonymous with marriage and love. The De Beers diamond company (a monopoly really) hired him to condition the public into associating a diamond ring with love. Before this, women's wedding rings were simply a gold band, but Bernays was able to

[22] Bernays, Edward – *Propaganda* page 63
[23] Orwell, George – *Nineteen Eighty-Four* page 187
[24] *New York Times* "Group of Girls Puff at Cigarettes as a Gesture of Freedom" (April 1, 1929)

use his propaganda techniques to condition (brain wash really) both men and women into believing that when a man proposes marriage to a woman, he needs to do so with a large diamond ring. "Diamonds are a girl's best friend," and "a diamond is forever." Get it?

It's foolish to deny the power of music and musicians, or to deny that songs and music videos are often very persuasive pieces of propaganda. Musicians often affect fashion, starting new trends and even creating new words and catch phrases. I'm sure you're familiar with "grills," "bling," and maybe "getting jiggy with it." Many listeners clearly copy the dress and style of their favorite musicians, and some songs are admittedly designed as antiwar protest anthems, or to bring attention to various social causes. Declassified documents show that the FBI wanted to dig up dirt on (or frame) John Lennon and deport him from the United States because his antiwar activities in the 1960s were undermining the government's pro war propaganda regarding Vietnam.[25]

It's not uncommon that concerts are held to raise money for various charities or causes. So if songs can be used to support the antiwar movement, or encourage people to act in a positive way, why is it that so many people scoff at claims that music can be equally influential in negative ways, and promote socially destructive behaviors as well?

It's undeniable that music can bring people joy or inspire them to help others—so why is it so many people deny that it can do exactly the opposite? The truth is, most artists, record labels, and studios know the power their music holds, good or bad, but will never betray the secret of their success.

[25] *BBC* "John Lennon FBI papers released" (December 20, 2006)

When people say "have a nice day" or "drive safely," they are encouraging those thoughts to permeate your mind. It feels good to hear positive and uplifting words of encouragement. Conversely, if someone tells you "you're an idiot" or insults you verbally, you'll literally feel bad, mad, or anxious, and can easily have your emotions and state of mind affected simply by hearing a few words. If hearing a few little words can affect your thought patterns, emotions and actions, then what do you think entire songs set to a melody or beat do to the mind?

It should be clear to anyone with common sense that music can motivate or guide people's thought patterns and act as a catalyst for behaviors and actions, and it would be foolish to think that certain power-hungry people in corporations, governments, or even a secret society, wouldn't want to harness this power for their own goals, using music and celebrities as pawns in their propaganda game.

Media critic and former dean of the University of California, Berkeley Graduate School of Journalism, Ben Bagdikian, writes in *The New Media Monopoly*, that "The possibilities for mutual promotion among all their various media is the basic reason the Big Five [News Corporation, Time Warner, Disney, Viacom, and Bertelsmann] have become major owners of all kinds of media. For example, actors and actresses in a conglomerate's wholly owned movie studio can appear on the same company's television and cable networks, photographs of the newly minted celebrities can dominate the covers of the firm's wholly owned magazines, and those celebrities can be interviewed on the firm's wholly owned radio and television talk shows. The conglomerate can commission an author from its wholly owned book

publishing firm to write a biography or purported autobiography of the new stars, which in turn is promoted on the firm's other media."[26]

Bagdokian notes the Big Five, "have power that media in past history did not, power created by new technology and the near uniformity of their political goals,"[27] and that, "Technically, the dominant media firms are an oligopoly, the rule of a few in which one of those few, acting alone, can alter market conditions."[28]

Neil Postman in his classic media analysis, *Amusing Ourselves To Death*, explains that before radio and television, when information was spread through newspapers and books, it was of much higher quality, and his goal was to emphasize that, "under the governance of the printing press, discourse in America was different from what it is now—generally coherent, serious and rational; and then how [today], under the governance of television, it has become shriveled and absurd."[29]

The book argues that television as a medium, compared to books and newspapers, is extremely limited in its ability to transmit quality information because it is packaged into small sound bites and brief segments that are only two or three minutes long, which cannot begin to convey the details, historical context, or the complex ideas needed to transmit a complete and quality message to the audience.

Postman concluded that our mass media infused future may be a mix between an Orwellian nightmare and

[26] Bagdikian, Ben - *The New Media Monopoly* page 8
[27] Bagdikian, Ben - *The New Media Monopoly* page 11
[28] Bagdikian, Ben - *The New Media Monopoly* page 5
[29] Postman, Neil - *Amusing Ourselves To Death* page 16

a Huxleyan circus,[30] saying, "In the age of advanced technology, spiritual devastation is more likely to come from an enemy with a smiling face than from one whose countenance exudes suspicion and hate. In the Huxleyan prophecy, Big Brother does not watch us, by his choice. We watch him, by ours. There is no need for wardens or gates or Ministries of Truth. When a population becomes distracted by trivia, when cultural life is redefined as a perceptual round of entertainments, when serious public conversation becomes a form of baby-talk, when, in short, a people become an audience and their public business a vaudeville act, then a nation finds itself at risk; cultural-death is a clear possibility."[31]

Some people point to the Tavistock Institute and the Rockefeller Foundation as a major cause of this evil for their studying of mainstream music and allegedly using their findings to influence society as a whole. The Tavistock Institute was created in Britain in 1946 to study group behavior and organizational behavior, and were funded by a large grant from the Rockefeller Foundation. In 2008 the Rockefeller Foundation's estimated assets were reported at $3.1 billion dollars, of which $137 million dollars were given away in grants.[32] This is the same foundation that funded the CIA's MK-Ultra experiments in mind control which began in the 1950s.

The notorious Nazi, Dr. Josef Mengele, was also funded by the Rockefeller Foundation to peruse Eugenics programs, [33] and later carried out horrific human

[30] The term "Huxleyan" refers to Aldous Huxley and his famous novel *A Brave New World*.
[31] Postman, Neil - *Amusing Ourselves To Death* page 155-156
[32] *FoundationCenter.org* "The Rockefeller Foundation"
[33] *San Francisco Chronicle* "Eugenics and the Nazis - the California connection" by Edwin Black (November 9, 2003)

experiments in the Auschwitz concentration camp in Germany.

Others point to Operation Mockingbird, a secret CIA program exposed in congressional hearings in 1975, which uncovered the Central Intelligence Agency was secretly paying the editors, reporters, and news readers at the major media outlets over one billion dollars a year in today's dollars,[34] to act as propagandists and gatekeepers for the government and the establishment.

Thomas Braden, who worked for the CIA and was a director of Operation Mockingbird, would later reveal, "If the director of the CIA wanted to extend a present, say, to someone in Europe—a Labour leader—suppose he just thought, this man can use fifty thousand dollars, he's working well and doing a good job—he could hand it to him and never have to account to anybody... There was simply no limit to the money it could spend and no limit to the people it could hire and no limit to the activities it could decide were necessary to conduct the war—the secret war...It was multinational."[35]

A Senate Select Committee in 1975, called the Church Committee (headed by Senator Frank Church) was created to investigate the American government's covert influence over the mainstream media, including broadcast news, newspapers, and magazines. According to the Church Committee's report that was published about their investigation, "The CIA currently maintains a network of several hundred individuals around the world

[34] Final Report of the Select Committee to Study Government Operations With Respect to Intelligence Activities. April 1976. pp. 191–201

[35] Thomas Braden, interview included in the Granada Television program, *World in Action: The Rise and Fall of the CIA* (1975)

who provide intelligence for the CIA and at times attempt to influence opinion through the use of covert propaganda. These individuals provide the CIA with direct access to a large number of newspapers and periodicals, scores of press services and news agencies, radio and television stations, commercial book publishers, and other foreign media outlets."[36]

After the Church Committee released its report, *Rolling Stone* magazine published an article on Operation Mockingbird and named various prominent journalists who were alleged to be involved with it, including reporters for *The New York Times, The Washington Post, Newsweek, Time magazine, The New York Herald Tribune, Miami News*, and others.

Sig Mickelson, former President of CBS, was later asked if the CIA still maintained relationships with reporters, and he answered, "Yeah, I would think probably, for a reporter it would probably continue today, but because of all the revelations of the period of the 1970s, it seems to me a reporter has to be a lot more circumspect when doing it now or he runs the risk of at least being looked at with considerable disfavor by the public. I think you've got to be much more careful about it."[37]

It's fairly well known that *Ms.* Magazine, started by feminist activist Gloria Steinem in 1972, is accused of being funded by the Illuminati in order to promote the

[36] Final Report of the Select Committee to Study Government Operations With Respect to Intelligence Activities. April 1976.
[37] *YouTube* "CIA Admits Using News To Manipulate the USA" (1975)

feminist revolution with the goal of breaking down the family structure and traditional gender roles.[38]

If we look back over two hundred years ago and simply read the confiscated writings of Adam Weishaupt and the other original Illuminati members, we can see that even back then they understood the power of controlling information. Some excerpts from these writings explain, "By establishing reading societies, and subscription libraries, and taking these under our direction, and supplying them through our labors, we may turn the public mind which way we will."[39]

"In like manner we must try to obtain an influence in the military academies (this may be of mighty consequence), the printing-houses, booksellers shops, chapters, and in short in all offices which have any effect, either in forming, or in managing, or even in directing the mind of man: painting and engraving are highly worth our care."[40]

"We get all the literary journals. We take care, by well-timed pieces [articles], to make the citizens and the Princes a little more noticed for certain little slips."[41]

"The great strength of our Order [organization] lies in its concealment; let it never appear in any place in its own name, but always covered by another name, and another occupation. None is fitter than the three lower degrees of Freemasonry; the public is accustomed to it, expects little from it, and therefore takes little notice of it…it may be a powerful engine in our hands."[42]

[38] *Bloomberg* "What Gloria Steinem, Henry Kissinger Have in Common: CIA Pay" by Charles Trueheart (February 22, 2008)
[39] Robison, John – *Proofs of a Conspiracy* p. 112
[40] Robison, John – *Proofs of a Conspiracy* p. 112
[41] Robison, John – *Proofs of a Conspiracy* p. 113
[42] Robison, John – *Proofs of a Conspiracy* p. 112

In George Orwell's *Nineteen Eighty-Four*, the Ministry of Truth was the department of the government that provided the citizens with all of their newspapers, films, textbooks, TV shows and novels. This department, Orwell wrote, "produced rubbishy newspapers, containing almost nothing except sport, crime, and astrology, sensational five-cent novelettes, films oozing with sex, and sentimental songs."[43] Their purpose was to keep the population distracted and out of the government's way so Party officials could maintain their power.

If you're not familiar with *Nineteen Eighty-Four*, it is a dystopic warning about how a corrupt government or group can manipulate the masses through the control of information, and is considered by many to be one of the greatest pieces of literature of all time. My previous book *Big Brother: The Orwellian Nightmare Come True* covers the eerie parallels between Orwell's fictional novel, and the very world we are living in right now, drawing from actual technology, government programs, and countless common sense examples that are making their way into the mainstream news.[44]

Only a complete moron would think that government agencies do not massively influence the mainstream media today. Even those who expect such manipulation are often surprised to learn the extent of its practice and power. As time goes on, and if people open their eyes to see what's really going on, more and more people will realize, like President Bill Clinton's former advisor Dick Morris, that "the conspiracy theorists are

[43] Orwell, George – *Nineteen Eighty-Four* page 38
[44] Not available in stores, but in stock at Amazon.com or in ebook on Kindle, Nook, iBooks, or Google Play

right."[45]

Let us now take a closer look at the mouth pieces and puppets held up as idols, gods and goddesses by millions of mentally enslaved mainstream music lovers. If it took seeing Illuminati symbolism in their videos for you to realize they are satanic scum, then you've been deaf, dumb, and blind, because if you simply listened to their lyrics or looked at the content of their character, it would have been as clear as day. The fact that you're reading this book right now shows you're on the right track though, and if you've only just caught a glimpse of their secret symbolism or heard rumors about it, get ready, because your eyes are about to be opened to a whole new world.

[45] *Fox News* "Hannity" Guest Dick Morris: Conspiracy Theorists are Right (March 30th 2009)

Rap and Hip Hop

Out of all the different genres of music, the emergence of Illuminati symbolism appears most prevalent in rap and hip-hop. An African-American pastor named G. Craig Lewis from EX Ministries out of Prairie, Texas said it's because, "The brothas aren't down with heavy metal," [46] referring to the use of satanic imagery and messages that, for some time at least, had become synonymous with heavy metal music.

One other likely reason for the Illuminati to be invoked in rap and hip hop is because the genre itself is largely dedicated to promoting a materialistic, hedonistic, violence driven message—at least mainstream hip-hop and rap, that is. Of course the genre has been hijacked and perverted by the music monopoly corporations that have twisted its theme into something completely contrary to the message of its founders. Since the Illuminati represent the ultimate pinnacle of power and evil, it is almost a natural evolution for rappers to move beyond portraying ordinary gangsters to wrapping themselves in the Illuminati flag as they pose as rich and powerful badasses. Invoking Illuminati imagery has become so

[46] *YouTube* "The truth behind hip-hop" by G Craig Lewis

popular in rap music that an episode of *The Cleveland Show* (an African American cartoon for adults) depicted the idea that a secret society made up of famous rappers (Kanye West, Nicki Minaj and others), were a part of the "Hip Hop Illuminati." The artists portrayed in the show actually did the voiceovers themselves. Kanye West and the others even rapped a short little song written for the show with lyrics like:

Illuminati starts shit that then becomes cool
Illuminati starts the trends that then becomes rules
Illuminati!

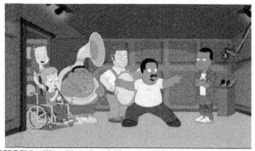

PHOTO: *The Cleveland Show's* "Hip Hop Illuminati" episode on Fox.

While there are a handful of successful rappers who stay true to the origins of the genre, it's quite obvious that the vast majority of mainstream rappers promote a shallow, ignorant, idiotic, materialistic, mentally enslaving message using keywords about making money, getting laid, partying 24/7, and other mindless jibber jabber.

Before we take a look at the blatant and disturbing imagery and messages in this music, I will reprint excerpts from a letter claimed to be written by a former music

executive who says he witnessed a secret meeting in 1991 where big wigs in the prison industry basically paid off record company executives to promote rap artists who glorify crime with the goal of encouraging listeners to get locked up in prison so the private prison industry could make more money. The letter, titled "The Secret Meeting that Changed Rap Music and Destroyed a Generation," first surfaced on the Internet in 2012 after a hip hop news website claimed they had received it in an e-mail and is quoted here in accordance with, and in full compliance with fair use laws in Section 107 of U.S. Copyright Law.

The letter starts off saying that in 1991 the writer witnessed what he called, "one of the biggest turning points in popular music, and ultimately American society." The author says that in the 1980s and 90s he worked for a major music company and was summoned to a meeting to "discuss rap music's new direction."

"Among the attendees," he writes, "was a small group of unfamiliar faces who stayed to themselves and made no attempt to socialize beyond their circle. Based on their behavior and formal appearances, they didn't seem to be in our industry. Our casual chatter was interrupted when we were asked to sign a confidentiality agreement preventing us from publicly discussing the information presented during the meeting."

At this point the writer says a speaker at the meeting revealed he worked in the prison industry. "He explained that the companies we work for had invested millions into the building of privately owned prisons and that our positions of influence in the music industry would actually impact the profitability of these investments. I remember many of us in the group immediately looking at each other in confusion. At the time, I didn't know what

a private prison was but I wasn't the only one. Sure enough, someone asked what these prisons were and what any of this had to do with us. We were told that these prisons were built by privately owned companies who received funding from the government based on the number of inmates. The more inmates, the more money the government would pay these prisons. It was also made clear to us that since these prisons are privately owned, as they become publicly traded, we'd be able to buy shares."

Many people are unaware that countless prisons are actually privately owned for-profit companies, not simply facilities owned by the government. These companies pay lobbyists to influence policies and judges to enact legislation and penalties that are profitable for the prisons.

The letter goes on, "Most of us were taken back by this. Again, a couple of people asked what this had to do with us. At this point, my industry colleague who had first opened the meeting took the floor again and answered our questions. He told us that since our employers had become silent investors in this prison business, it was now in their interest to make sure that these prisons remained filled. Our job would be to help make this happen by marketing music which promotes criminal behavior, rap being the music of choice. He assured us that this would be a great situation for us because rap music was becoming an increasingly profitable market for our companies, and as employees, we'd also be able to buy personal stocks in these prisons."

The man claims he was deeply disturbed after the meeting but never spoke out publically out of fear of losing his job or something happening to his family. "As the months passed, rap music had definitely changed

direction. I was never a fan of it but even I could tell the difference. Rap acts that talked about politics or harmless fun were quickly fading away as gangster rap started dominating the airwaves. Only a few months had passed since the meeting but I suspect that the ideas presented that day had been successfully implemented. It was as if the order has been given to all major label executives. The music was climbing the charts and most companies where more than happy to capitalize on it. Each one was churning out their very own gangster rap acts on an assembly line. Everyone bought into it, consumers included. Violence and drug use became a central theme in most rap music. I spoke to a few of my peers in the industry to get their opinions on the new trend but was told repeatedly that it was all about supply and demand. Sadly many of them even expressed that the music reinforced their prejudice of minorities."

Two years later, he says, he left the business and a few years later in the late 1990s when the Internet emerged he said he was able to do more research into the private prison industry. "Now that I have a greater understanding of how private prisons operate, things make much more sense than they ever have. I see how the criminalization of rap music played a big part in promoting racial stereotypes and misguided so many impressionable young minds into adopting these glorified criminal behaviors which often lead to incarceration."

After saying twenty years of guilt had been weighing on his shoulders he decided to write his letter and e-mail it to various rap and hip hop websites. He also wrote that he planned on remaining anonymous but urged others who attended the supposed 1991 meeting to tell their stories as well.

The letter is a very interesting read, but unless others come forward and confirm this person's story, there is no way to verify whether or not this meeting took place. Of course it's possible this story is a hoax written hoping to attract people to the author's website, although I do believe that such a plan was put in motion, but whether or not the person who wrote this letter was a part of that plan is not clear.

Jay-Z

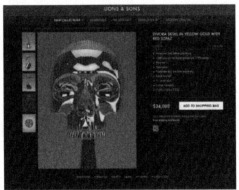

PHOTO: A $34,000 golden skull given to Jay-Z for Father's Day in 2012 by fellow rapper Kanye West.

The rapper with the most Illuminati rumors surrounding him is perhaps Jay-Z, the stage name of Sean Carter, who is one of the most successful and wealthy rappers in history, with an estimated net worth of approximately $500 million dollars according to *Forbes*

magazine.[47] He has sold approximately fifty million albums; he's won 17 Grammy Awards, and is even friends with President Barack Obama, whom he held a fundraiser for at his 40/40 Club in New York City to help get him reelected for a second term in 2012.

Jay-Z even hit the campaign trail with Obama, appearing onstage with him at events and was featured in an official campaign commercial so he could reach people who didn't follow politics and urge them to get off their couch and vote for Obama. He and Barack are supposedly "friends" and Jay-Z is reported to have Obama's personal cell phone number so the two can talk or text with each other whenever they want. Of course, he's been invited to the White House several times to meet with Obama as well.[48]

Jay-Z's entire rap persona is that he's a rich hustler and former drug dealer from the projects, and his songs are predictable portrayals of a dream life filled with money and girls (Big Pimpin') as most listeners live vicariously through the fantasies his songs paint. While this can be fairly expected and understandable, what is more surprising is the fact that Jay-Z incorporates blatant Illuminati hat-tips and symbolism into several of his songs and videos, and he himself appears to be an Aleister Crowley fan—the infamous Satanist—who wrote instructions for getting magic power by sacrificing children to Satan.[49]

[47] *Forbes* "The Forbes Five: Hip-Hop's Wealthiest Artists 2011" by Zack O'Malley Greenburg (3/09/201)
[48] *MTV.com* "Jay-Z: President Obama Was Playing The Blueprint When I Called Him" by Jayson Rodriguez (Feb 19 2010)
[49] Crowley, Aleister – *Magick: In Theory and Practice* p.95-96

In a behind the scenes interview during the making of Rihanna's "Run This Town" music video, Jay-Z was wearing a black sweatshirt with "Do What Thou Wilt" emblazoned across the front, the infamous credo of Aleister Crowley, meaning "do whatever you want no matter the consequences, you are your own God." Many people who have seen the picture of Jay-Z wearing this sweatshirt think the image was photoshopped, but it is real, and is simply a screen shot taken from his videotaped interview on the set of Rihanna's "Run This Town" shoot.

Since Jay-Z is wearing a sweatshirt with Aleister Crowley's credo printed on the chest, let's take a brief look at some of Crowley's writings and the philosophies and activities he promoted. Crowley said a demon possessed his wife and dictated to him the contents of what would become the Book of the Law, which is where the "do what thou wilt" credo is found. His demon possessed wife revealed the following pieces of advice:

"Compassion is the vice of kings: stamp down the wretched & the weak: this is the law of the strong, this is our law and the joy of the world."[50]

"Worship me with fire & blood; worship me with swords & with spears, is the command. Let the woman be girt with a sword before me: let blood flow to my name. Trample down the Heathen; be upon them, o warrior, I will give you of their flesh to eat! Sacrifice cattle, little and big: after a child."[51]

"Mercy let be off: damn them who pity! Kill and torture; spare not; be upon them! The Best blood is of the moon, monthly: then the fresh blood of a child."[52]

[50] Crowley, Aleister – *The Book of The Law* page 31
[51] Crowley, Aleister – *The Book of The Law* page 40
[52] Crowley, Aleister – *The Book of The Law* page 41

"I am in a secret fourfold word, the blasphemy against all gods of men. Curse them! Curse them! Curse them! With my Hawk's head I peck at the eyes of Jesus as he hangs upon the cross."[53]

Aside from wearing a shirt with an infamous occult credo on the front, Jay-Z's Rocawear clothing line actually decided to print some up themselves and sold a few different designs of Illuminati and Masonic t-shirts for a period of time which had an all seeing eye on the chest with 13 rays of light coming out of it along with various other occult symbols. The Rocawear company is no small operation and is valued at several hundred million dollars.

His very name, Jay-Z, means Jehovah, the Latin name for God in the Old Testament, and he often refers to himself as "Hov," short for Jehovah, because he considers himself to be a god. In his song *D'Evils* he raps a verse where he says he never prays to God, he prays to Gotti (John Gotti the gangster) and in "Dirt Off Your Shoulder" some people believe a verse says "Middle finger to the Lord," while others insist he says "law," instead. In "Empire State of Mind" he raps a verse clearly saying, "Jesus can't save you, life begins when the church ends." He even admits putting "hidden messages" in his music.[54]

While people can expect explicit lyrics in rap music, Jay-Z sinks to an unprecedentedly low level in his collaboration with Kanye West (or Kanye Pest as I call him) and Nicki Minaj in the song "Monster" where everyone on the track raps about how "monstrous" and

[53] Crowley, Aleister – *The Book of The Law* page 47
[54] *MTV.com* "Jay-Z Calls His Way With Words The 'Rain Man Flow'"by Gigi Abrantes (8/28/09)

evil they are. In one line Jay-Z brags, "I rape and pillage your village, women and children."

His trademark gesture is making a pyramid using his two index fingers and thumbs while holding it up over one eye, symbolizing what many believe is the Illuminati's All-Seeing Eye, and he has made repeated occult and Illuminati references in his music, but not as a way to expose the activities of the organization, but rather it appears to be a tribute to them. It's obvious that Jay-Z is familiar with the invisible empire and, in my opinion, chose to aid them and wrap himself in their symbols instead of fight against them or expose them.

Jay-Z is the founder of Roc-A-Fella Records, a name that appears to refer to the Rockefeller Illuminati family, a very powerful and infamous family followed by a long list of allegations and New World Order activities and elite secret society affiliations. The Rockefeller family has had their tentacles wrapped around everything from the Council on Foreign Relations and the Bilderberg Group, to funding the CIA's MK-Ultra mind control experiments and more. In 2004 Jay-Z sold Roc-A-Fella Records for $10 million dollars to Def Jam Records, owned by Russell Simmons, who then made Jay-Z CEO.[55]

Jay-Z's mentor, a fellow rapper and producer who goes by the name Jaz-O, meaning Jaz the Originator, did an interview with *BlokTV* where he stated that Jay-Z is affiliated with secrets societies that practice homosexual rituals.[56] Jaz-O made it clear that he wasn't saying Jay-Z

[55] *MTV.com* "Jay-Z, Dame Dash Sell Roc-A-Fella Records; Jay Named Def Jam Prez" by Rashaun Hal (Dec 8 2004)

[56] *BlokTV* "Jaz-O Interview part 2 Says Jay-Z is affiliated with secret societies that engage in homosexuality" (posted to YouTube December 7, 2010)

engaged in these gay rituals himself, but he believes that he is closely aligned with people who do.

"He is in cahoots with those individuals in those type of brotherhoods and societies who engage in homosexual activities. I did not say he was a homo, but if you want to make that assumption, you can...There is only two ways I could know if the dude is a homo. One is if I saw it, or two is if I did it, and none of those things apply....Yeah, he is in cahoots with those brotherhoods and the people who have money on his level. Yes, they do engage in a lot of homosexual activity, and they're all in cahoots with each other."[57]

It's interesting that Jay-Z does not write lyrics down on paper when he's coming up with songs anymore, explaining, "I used to write all the time, until I started going into the rain man thing," which he hasn't elaborated on, but likely refers to when he discovered some accelerated learning techniques or memory improvement strategies like ancient mnemonics and other art of memory methods. Some believe his "rain man thing" refers to channeling a demonic entity who writes his music for him.

In 2003 he announced that he would retire from making music after the release of *The Black Album*, which of course wasn't true and was just a shamefully obvious publicity stunt to generate headlines and encourage his fans to buy more of his music. Of course, three years later he announced he was coming out of retirement with a new album and then continued making music.[58]

[57] Ibid
[58] *Associated Press* "Jay-Z ends 'worst retirement in history'" (9/14/2006)

A song titled "Lucifer" was released in 2004 by Danger Mouse on his *Grey Album* that contains some disturbing messages from Jay-Z the public should know about. When listening to the song it's clear that several sound bites are playing backwards and are unintelligible. But when the song is played in reverse, however, you can clearly hear Jay-Z saying, "Six six six, murder Jesus," and talking about murdering Catholics, leaving "niggas on death's door" and introducing people to demons.

It's important to stress that this backwards message is not a "subliminal message" meant to be picked up subconsciously by the listeners. It is more of a marketing ploy and a way to get Jay-Z fans talking about how "cool" the backwards satanic messages are. It's also important to understand that the messages are clearly understandable when the track is played backwards and the disturbing sound bites are not the result of someone interpreting a series of sounds as saying such things. People are not "hearing things" or "reading too much into the track." The blasphemous sound bites are as clear as day once the song is played in reverse.

When people hear the allegations of the reverse messages in the song "Lucifer," most Jay-Z fans refer to the original song "Lucifer" which is found on Jay-Z's *Black Album* and didn't hear anything out of the ordinary. That's because Danger Mouse remixed the song for his *Grey Album* and edited Jay-Z's voice to say the disturbing things found in the song. Jay-Z never denounced Danger Mouse for doing such a thing (or threatened legal action for misappropriation of image or copyright infringement) but instead actually praised the remix, saying he was "honored" and "I think it was a really strong album. I champion any form of creativity and that was a genius idea to do it, and it sparked so many others like it. There

34

are other ones that, you know, it's really good, there are other ones that, because of the blueprint that was set by him, that I think are a little better. But, you know, him being the first and having the idea; I thought it was genius."[59]

If any reasonable person had their words twisted to say such things they would take legal action, or at the very least, denounce the use of their voice in such a way, but instead Jay-Z was honored. In a video posted to YouTube that was shot inside the studio when Jay-Z was recording the song "Lucifer" for his *Black Album* you can hear him make a comment sounding like he's bragging, "I swear I never read the Bible in my life."[60]

Prodigy of Mobb Deep wrote a several page letter while in prison for a weapons charge that mentioned Jay-Z and the Illuminati, saying, in part, "Jay-Z and Jaz-O were both raised (in their teenage years) in Dr. [Dwight] York's 'Nuwabian' community in Bushwick Brooklyn... Jay-Z knows the truth, but he chose sides with evil in order to be accepted in the corporate world and promotes the lifestyle of the beast instead...Jay-Z is a God damn lie."[61]

It's outrageous that people were not outraged when the President of the United States attended a fundraiser put on by this kind of garbage entertainer, let alone putting the rapper in an official campaign ad to boot.[62] It also shows how low Barack Obama would go

[59] *Techdirt.com* "Jay-Z Explains He Is 'Honored' To Have His Work Remixed By Others" by Mike Masnick (November 19th 2010)
[60] YouTube "Jay-Z Making 'Lucifer'" (posted September 11th 2008)
[61] ThisIs50.com "Letter from the Pen: Prodigy Takes Shots at Rell, Rick Ross, and Names His Favorite 40 MC's" (March 8, 2009)
[62] *Billboard.com* "Jay-Z Speaks Out in Obama Campaign Ad" by David Greenwald (October 15, 2012)

to energize his African American base to get out the vote. A slick political ploy, no doubt, that worked like a charm.

Jay-Z once denied the Illuminati rumors in an interview on Hot 97 after host Angie Martinez asked him if any of the "Illuminati Devil worshiping Freemason" claims were true, saying "I don't know where it came from, I don't know where it started." When Martinez asked if he was "messing with people and doing this on purpose," he responded, "No, not me. Never done that before. Why would I do that? That's retarded. To be honest with you I really think it's really silly."[63]

On his album *Magna Carta Holy Grail* he addressed the rumors again in a song titled "Heaven" where he said "Conspiracy theorists screamin' Illuminati / They can't believe this much skill is in the human body." Really? He can't believe people are saying these things? Wearing an Aleister Crowley sweatshirt, saying blasphemous things about God and Jesus, flashing Illuminati hand signs and using occult imagery in his videos, visiting the White House several times and hitting the campaign trail with Obama to help get him elected? Portraying the image of a big spending high rolling thug without a care in the world. Wearing a 5% Nation medallion, a religious organization started in Brooklyn by a man calling himself God and saying that his followers were the spiritual elite of the world who knew the true secrets of the Universe. Launching the careers and molding the image of other Illuminati icon artists like Rihanna, and Kanye West—I can't imagine why people would say these things about him.

[63] Hot 97 FM New York "The Angie Martinez Show" Interview with Jay-Z

While Jay-Z is not sitting in on Illuminati meetings where they plan the next war or discuss the up and coming economic trends, he is a willing servant of them and has been built up as an Illuminati idol for the psychologically sedated masses to worship and mimic, promoting a "do what thou wilt" anything goes, hedonistic, live for the now lifestyle, which always leads to destruction, disappointment, debt, and despair.

Kayne West

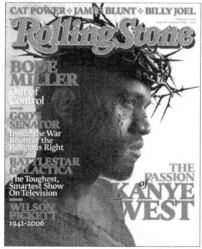

PHOTO: *Rolling Stone* cover depicting Kanye West as Jesus.

Another one of the biggest Illuminati wannabes is Kanye West, (or Kanye Pest as he should be referred to) who burst onto the music scene in 2004 with his single "Jesus Walks," which got mainstream airplay giving the impression that Kanye was a good Christian boy who

loved Jesus. Once in the spotlight though, Kayne's image and message quickly took a turn for the worse, ultimately leading him to become one of the biggest promoters of Illuminati symbolism and materialism, not to mention developing a God complex so huge it's virtually unmatched in the entertainment industry.

He miraculously has won eight Grammies, and in 2008 was awarded the "Hottest MC in the Game" by MTV, and even made *Time* magazine's 100 most influential people in 2005.[64] I say miraculously because it's a miracle such a talentless troll could actually achieve mainstream success, but on second thought with millions of mentally enslaved morons who eat up whatever the mainstream serves, such popularity among the peasants is not all that surprising.

A critical boost to Kanye West's career was working for Jay-Z's Roc-A-Fella Records and he was considered Jay-Z's protégé while helping produce his 2001 album *The Blueprint.*

West's ego grew larger than his wallet as his career took off, and he became one of the highest profile rappers to start posing as if he had some connection to the Illuminati, wearing clothes with Baphomet symbols on them, name-dropping the Illuminati in a few songs, and even saying he sold his soul to the Devil.[65] Kanye West also isn't shy about his God complex, appearing on the cover of *Rolling Stone* in 2006 as Jesus, wearing a crown of thorns, and later releasing a track titled "I Am a God," on his *Yeezus* album; Yeezus being a perversion of the name Jesus.

[64] *MTV.com* "Jay-Z, Kanye West, Alicia Keys Make Time's List Of Most Influential People" by James Montgomery (Apr 11, 2005)
[65] "Sailing not Selling" by Jhene Aiko featuring Kanye West

His God complex is so huge that after he failed to win Best New Artist in 2004 at the *American Music Awards*, he stood up and stormed out of the show, saying, "I was the best new artist this year," and claimed he got "robbed." At the 2006 MTV Europe awards he ran on stage as the award for best video was being presented to someone else and started arguing that he should have won. Then of course there was the infamous incident in 2009 when he stole the spotlight from Taylor Swift after she won an *MTV Video Music Award* for Best Female Video.

After Beyoncé gave birth to Jay-Z's child, named Blue Ivy, Kanye gave Jay-Z a gold plated human skull covered in gemstones valued at $34,000 for Father's Day.[66] He even reportedly had it shipped via a private jet. Freemasons and other occultists often have a human skull (or replica) on their desk or in their Chamber of Reflection to remind them of their mortality and impending death, to inspire them to achieve all of their goals in this life here and now, since they do not believe in an afterlife.

In the season premiere of the *Cleveland Show* in November 2012, the episode revolved around the "Hip Hop Illuminati," a secret society said to control pop culture and the music industry. Kanye West, Nicki Minaj, Bruno Marrs, and Will.i.am all lent their actual voices to the show and recorded the voice-overs as they played themselves in the episode. Kanye even rapped a little song in the episode about the Illuminati controlling society.

He secured himself a part in pop culture forever when he knocked up Kim Kardashian, the antichrist of

[66] *CBS Los Angeles* "Happy Father's Day! Kanye Gives Jay-Z $34,000 Golden Skull" (June 28, 2012)

entertainment, while she was still married to NBA player Kris Humphries.[67] This Baphomet bimbo got a "blood facial" on her TV show[68] in an attempt to maintain her youthful beauty, which involved basically smearing human blood on her face, reminiscent of Elizabeth Bathory the "blood countess" from the Kingdom of Hungary, who in the 1600s, murdered dozens of virgins so she could bathe in their blood believing it would keep her young.[69]

After they were dating for a while, Kanye's baby's momma also posted a few photos to her Instagram account showing off several new bracelets, one of which featured an All-Seeing Eye and another that people said looks like a Baphomet head,[70] leading some to wonder if Kanye introduced her to the world of occult and Illuminati symbolism.

This scumbag's antics and obvious egomania could have been sparked by studying occult philosophies from Aleister Crowley and others who teach that you are God, or can become God by evolving your consciousness through various satanic practices. After all, it was Satan in the Garden of Eden who said that Adam and Eve could "become like God" by partaking in the forbidden fruit to open their eyes and mind to the secret powers Satan offered.

[67] *Eonline.com* "Pregnant Kim Kardashian: 'I Don't Want to Be Married to Kris Humphries When I Have the Baby'" by Natalie Finn (February 6, 2013)
[68] *Kourtney and Kim Take Miami* on the E! Channel
[69] *New York Daily News* "Kim Kardashian's $1,500 'vampire facial' is a Hollywood hit that promises younger, firmer-looking skin" by Nicole Lyn Pesce (March 12, 2013)
[70] Instagram.com/KimKardashian (April 5th 2013)

Lil Wayne

PHOTO: A screenshot of Lil Wayne's video "Love Me" depicting him as Satan.

One of the ugliest and dumbest demonic dirt bags in the music industry is Lil Wayne (ghetto speak for Little Wayne), who was groomed by Cash Money Records founder Bryan "Birdman" Williams (aka Baby) since Wayne was a child and shown the ways of the business. It's a mystery to me how so many people could purchase and enjoy Lil Wayne's music when he sounds like a grunting gorilla going through a meat grinder, but with much of the population dumbed down and degenerating intellectually, I guess he is just a reflection of our dark, rotting culture.

Aside from using obvious demonic imagery in his music videos, such as literally having devil horns coming out of his head and keeping women locked up in cages,[71] Lil Wayne is also plagued by allegations that he is gay or

[71] *YouTube.com/LilWayneVEVO* "Love Me by Lil Wayne ft. Drake, Future" (posted February 14th 2013)

bisexual,[72] with some of his detractors calling him "Little Gay," instead of Little Wayne.

The gay allegations stem from Lil Wayne (or Little Wanker, Little Stain, or Little Pain as I call him) kissing his mentor "Birdman" aka "Baby" on the lips on various occasions.[73] When Birdman was asked how women feel about kissing him while wearing a grill (teeth bling), Little Wayne interrupted the host to inject, "Hey! I'm the only one he kisses," and reached over and kissed him right then and there![74] The hosts on BET conducting the interview literally flew back in their seats and the audience gasped.[75]

Rapper Fat Joe has said that he believes a gay mafia runs the hip hop industry,[76] which is interesting because music mogul Clive Lewis, the man behind many popular acts, later revealed in his memoir that he is bisexual.[77] In an interview with Howard Stern, Suge Knight said there were a ton of closet gay rappers and even claimed that Dr. Dre was gay and allegedly had a sexual relationship with some dude named Bruce.[78]

Professor Griff claims that Tupac was asked by a famous record producer to have sex with him, but "When

[72] *MediaTakeOut.com* "Out of the Closet?" (August 05, 2011)

[73] *Bossip.com* "Original Footage Of Lil Wayne & Baby Kissing On Rap City Circa 2002!"

[74] *BET* "106 & Park" Lil Wayne and Baby Kiss on the Lips

[75] Ibid

[76] *VLADTV* "Fat Joe thinks the Gay Mafia Controls Hip-Hop" (November 7th 2011)

[77] *Rolling Stone* "Clive Davis Comes Out in New Memoir" by David Browne (February 19, 2013)

[78] *The Howard Stern Show* – Suge Knight Calls Dr. Dre Gay (2012)

Tupac said 'no,' that's when he was marked for death."[79] Griff also said, "If rappers didn't shoot one another up—if somebody didn't get raped, or somebody didn't get robbed—they would provide an incident for something to go down, because they're setting hip hop up for destruction."[80]

Griff also believes, "Homosexuality is on the rise, and they made the new cleavage become the butt crack," referring to people wearing saggy pants exposing their underwear or butt, a style some claim came from gay prisoners who advertised that they were gay by showing off their butt cracks.

Child star Corey Feldman of *Goonies* and *The Lost Boys* fame, made an even more shocking claim when talking with ABC's *Nightline* when he said that pedophiles run Hollywood and the entertainment industry. "I can tell you the number one problem in Hollywood was, is, and always will be, pedophilia. That's the biggest problem for children in this industry...It's the big secret."[81]

Some people point to the Boule, a black all-male fraternity, as the source of success for many African American artists, calling it the "Black Skull and Bones" society, referring to the notorious Illuminati recruiting ground founded in 1832 at Yale University that includes numerous powerful politicians and business moguls in their ranks. Perhaps the most well-known Skull and

[79] *DiaryofaHollywoodStreetking.com* Interview: "Professor Griff Reveals What He Believes is Responsible for Hip Hop's Demise!" by Jacky Jasper
[80] Ibid
[81] *ABC News Nightline* "Actor Corey Feldman Says Pedophilia No. 1 Problem for Child Stars, Contributed to Demise of Corey Haim" By Steven Baker and David Wright (August 10, 2011)

Bones members are Presidents George W. Bush and his father George Bush senior, as well as George W. Bush's grandfather Prescott Bush, and even his uncle, Jonathan Bush, who is an elite bankster whose firm Riggs Bank was fined a record $25 million dollars in 2004 for allegedly laundering Saudi money.[82]

Jonathan Bush was also a major contributor and fundraiser for his nephew's presidential campaign. George W. Bush's opponent in the 2004 presidential election was fellow Skull and Bones member John Kerry,[83] showing that this elite superclass cabal had both bases covered, the Republican candidate, and the Democrat candidate, so whoever was elected president, it would be a win for the Illuminati.

Skull and Bones' initiation involves some strange and alleged homosexual rituals, and many people believe certain circles within the Boule involve similar kinds of rituals for the black men associated with them. Others believe that Little Wayne and other rappers are practitioners of Enochian sex magic, a strange practice that involves bizarre sexual behaviors to achieve altered states of consciousness said to allow them to gain metaphysical power over the Universe.

Regardless of exactly how Lil Wayne became one of the world's most famous rappers, it's clear that he is anything but subtle when it comes to using satanic imagery in his music videos and its clear exactly who he is pledging his allegiance to. It's also interesting to note that Little Wayne, like Jay-Z, does not write his lyrics

[82] *Washington Post* "Web Site Cites Bush-Riggs Link" by Kathleen Day" Page E02 (May 15, 2004)
[83] *CBS News* "Skull and Bones" by Rebecca Leung (February 11, 2009)

down anymore, and also does "the rain man thing," fueling speculation that he is channeling a demon which feeds him his words.

Drake

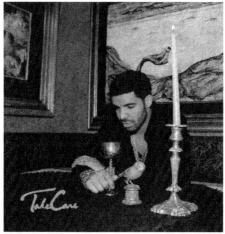

PHOTO: Drake's album cover featuring an owl statue many believe is a hat tip to the Bohemian Grove and the Illuminati.

Another mainstream rapper who's believed by some to be a closet gay or bisexual is Drake, a preppy pretty boy who looks dramatically different than the typical tatted up wannabe thugs often found in hip hop. Apparently, in my opinion, there's a market for a token gay looking rapper or the industry is possibly using Drake to warm people up to the first mainstream rap artist who will come out of the closet as gay. The day is coming, and depending on when you're reading this book, it may already be here, when a gay rapper will be pushed to

superstardom as a household name and hailed as a hero and role model for people to look up to and idolize.

After getting signed by Lil Wayne's Young Money Entertainment, Drake (whose real name is Aubrey, a gay sounding name, in my opinion, if I've ever heard one) adopted the symbol of an owl as his logo—an owl looking almost identical to the mascot of the Bohemian Grove. Drake wears t-shirts featuring the owl; he put it on his album cover, and even has a tattoo on his right shoulder of the mysterious image.

The Bohemian Grove is a 2700-acre, all-male elite retreat located in the vast redwood forest of Sonoma County, California about an hour north of San Francisco. Each July the Grove holds a 2-week long "encampment" where the most powerful men on the planet gather for a men's retreat where they can rub elbows with other political and industry elite and serves as an informal off-the-record consensus building environment for the Illuminati.[84]

During this annual meeting, which consists of approximately 1500 men, there are numerous daily lectures, called Lake Side Talks, given every afternoon which offer an insider's view into various sectors of society, given by members of the political, economic, military, and media elite.[85]

The Bohemian Grove's logo is an owl because an owl can see in the dark and represents wisdom since it can see while so many other creatures are basically blind.

[84] *San Francisco Chronicle* "The Chosen Few: S.F.'s exclusive clubs carry on traditions of fellowship, culture, and discrimination" by Adair Lara (July 18, 2004)

[85] Phillips, Peter - *A Relative Advantage: Sociology of the San Francisco Bohemian Club. A Doctoral Dissertation* (1994) Page 127

The Dictionary of Symbols explains, "In the Egyptian system of hieroglyphs, the owl symbolizes death, night, cold and passivity. It also pertains to the realm of the dead sun, that is, it is of the sun which has set below the horizon and which is crossing the lake or sea of darkness."[86]

A forty-foot tall concrete "owl" statue stands near the banks of the Russian River inside the Bohemian Grove, and every year is the site of the annual Cremation of Care ceremony where a life-size human effigy is "sacrificed" in a bizarre theatric reenactment of a human sacrifice. [87] The elaborate ritual is carried out by members wearing black hooded robes as they burn the effigy on an altar while standing in front of the huge statue after using the "eternal flame" to light a torch that is then used to sacrifice "Care," as they call the effigy, as they symbolically cast off their cares or burn their conscience. The statue looks more like a giant demon than an owl, and is believed by many to represent Moloch, an ancient god from thousands of years ago who people were sacrificed to.

This ritual seems to be a modern version of what the ancient Canaanites did in Biblical times, as was written about in the Bible's *Book of Leviticus*, where it reads, "Don't sacrifice your children on the altar fires to the god Molech." (Leviticus 18:21). Yes, this is the annual ritual performed at the Bohemian Grove to kick off the Illuminati's two week encampment.

So it appears that Drake (real name Aubrey) got a little more specific than others who use generic Illuminati imagery, and has adopted the same symbol as this

[86] Cirlot, J.E. – *The Dictionary of Symbols* Page 235-236
[87] *Dark Secrets Inside Bohemian Grove* (2000) by Alex Jones

notorious elite retreat, which includes many of the world's most wealthy and powerful men as members. There have been a lot of rumors aimed at the Bohemian Grove over the years, not only about Satanism, but homosexuality as well,[88] so maybe, in my opinion, Drake (Aubrey) would fit right in there, especially since he appears to be a fan of the club by using what looks to be a nearly identical logo as his own.

Rick Ross

PHOTO: Rick Ross in his music video "Pirates" sitting on a Baphomet throne adorned with human skulls.

One of the biggest phonies in the music industry is the pig headed poser "Rick Ross," whose real name is Robert Wallace. This Shamu looking fool took the stage name "Rick Ross" after the real Rick Ross, aka Freeway

[88] *RT America* "Alex Jones on gay rituals of Bohemian Grove" (July 15th 2011)

Ricky Ross, the infamous cocaine dealer from the 1980s whose suppliers were CIA assets involved with the Iran Contra Affair.[89] Robert Wallace (the fake Rick Ross, or Pig Ross as I like to call him) was a former corrections officer at a prison who rose to fame in the rap game after adopting his "Rick Ross" persona, even growing a beard like the real Rick Ross, as he basically, in my opinion, stole his entire identity.[90]

Not only has (the fake) Rick Ross posed as a drug dealer,[91] but he's also posed as a street gangster, name dropping Larry Hoover, a famous leader of the Gangster Disciples, angering the street gang and resulting in death threats from real Gangster Disciples, causing him to cancel his 2012 tour.[92] Someone actually shot at him causing him to crash his Rolls Royce in Fort Lauderdale, Florida.[93] The dude is morbidly obese and has a beer belly the size of Boston, but acts like he's a tough guy and a hard core Illuminati gangster.

"Rick Ross" took his posing to a whole new level when he released a song titled "Freemason" with lyrics bragging about having ancient wisdom more valuable than gold. The song caused "Rick Ross" to get called out face to face on camera by a Freemason who was pissed that he was falsely claiming to be associated with this ancient esoteric fraternity. Freemasonry has long been

[89] *Spin* "The Real Rick Ross Would Like His Name Back Now, Please" by Brandon Soderberg (August 31, 2012)
[90] Ibid.
[91] Rick Ross's "9 Piece" featuring T.I.
[92] *Rolling Stone* "Rick Ross Cancels Tour Dates Over Gang Threats" (December 7th 2012)
[93] *Los Angeles Times* "Rick Ross crashes car after gunshots fired in Florida" by August Brown (January 28, 2013)

seen as an elite secret society that teaches its members "the mysteries," or the ultimate secrets of life.

"Freemasonry is a fraternity within a fraternity—an outer organization concealing an inner brotherhood of the elect...the visible society is a splendid camaraderie of "free and accepted" men enjoined to devote themselves to ethical, educational, fraternal, patriotic, and humanitarian concerns. The invisible society is a secret most august fraternity whose members are dedicated to the service of a mysterious arcanum arcanorum (secret of secrets)," wrote Manly P. Hall, considered one of Freemasonry's greatest philosophers.[94]

While the majority of people see Masons simply as a local community group or charity, some of the fraternities' most respected members like Manly P. Hall, have revealed that there is an inner circle of mystics who supposedly know very powerful and occult knowledge that enables the select few "adepts" as they are called, to "evolve" into gods.

Famed Freemason Albert Pike wrote, "The True Word of a Mason is to be found in the concealed and profound meaning of the Ineffable Name of Deity...and which meaning was long lost by the very precautions taken to conceal it. The true pronunciation of that name was in truth a secret, in which, however, was involved the far more profound secret of its meaning. In that meaning is included all the truth that can be known by us, in regard to the nature of God."[95]

These teachings, because of their power, are kept secret from all but a small number of Masons who achieve

[94] Manly P. Hall, 33rd Degree Mason in *Lectures on Ancient Philosophy* page 433
[95] Pike, Albert – *Morals and Dogma* page 697

the 33rd degree, or 33rd level within the organization. Pike also wrote that "Masonry, like all the Religions, all the Mysteries, Hermeticism and Alchemy, *conceals* [emphasis in original] its secrets from all except the Adepts and Sages, or the Elect, and uses false explanations and misinterpretations of its symbols to mislead those who deserve only to be misled; to conceal the Truth, which it [the Mason] calls Light, from them, and to draw them away from it."[96]

Many critics of Freemasonry claim that this hidden knowledge is "satanic" and that the "royal secret" of high level Masons is that they worship Satan. Such allegations are not just pulled out of thin air, but are hinted at within the writings of some of Freemasonry's most famous and respected members. Albert Pike, for example, wrote in his book *Morals and Dogma*, "Lucifer, the Light-bearer! Strange and mysterious name to give to the Spirit of Darkness! Lucifer, the Son of the Morning! Is it he who bears the Light, and with its splendors intolerable, blinds feeble, sensual, or selfish souls? Doubt it not!"[97]

Earlier in the book, Pike has this to say about the subject, "...for Satan is not a black god, but the negation of God. The Devil is the personification of Atheism or Idolatry. For the Initiates, this is not a Person, but a Force, created for good, but which may serve for evil. It is the instrument of Liberty of Free Will. They represent this Force, which presides over the physical generation, under the mythological and horned form of the God Pan; thence came the he-goat of the Sabbat, brother of the

[96] Pike, Albert – *Morals and Dogma* page 104-105
[97] Pike, Albert – *Morals and Dogma* page 321

Ancient Serpent, and the Light-Bearer."[98]

Many people insist that Freemasonry is just a men's fraternity and nothing more, but Pike wrote, "Every Masonic Lodge is a temple of religion; and its teachings are instruction in religion."[99]

When trying to understand the opposing claims about what Masonry is and what the inner circle actually believes, it becomes much clearer when Pike himself explains, "The people will always mock at things easy to be misunderstood; it must [and] needs [to] have imposters. A Spirit...that loves wisdom and contemplates the Truth close at hand, is forced to disguise it, to induce the multitudes to accept it...Fictions are necessary to the people and the Truth becomes deadly to those who are not strong enough to contemplate it in all its brilliance...In fact, what can there be in common between the vile multitude and sublime wisdom? The truth must be kept secret, and the masses need a teaching proportioned to their imperfect reason."[100]

So with a history of powerful members and being supposed keepers of the "royal secret" of how Man can become god, it's easy to see why rappers like Rick Ross, looking to give the impression that they are powerful masters of the Universe, would claim an affiliation with Freemasonry.

Freemasonry goes hand in hand with the Illuminati since the inner circle of adepts or members of the secret society within the secret society are considered to be a branch of the Illuminati. Adam Weishaupt, the founder of the Illuminati in Bavaria, Germany (often called the

[98] Pike, Albert – *Morals and Dogma* page 102
[99] Pike, Albert – *Morals and Dogma* page 213
[100] Pike, Albert – *Morals and Dogma* page 103

Bavarian Illuminati) successfully infiltrated Freemasonry in 1782 in Wilhelmsbad, Germany and created an inner circle of what he called "Illuminated Masonry." Rick Ross is so dumb I doubt he could even read a book on Freemasonry, let alone understand it or contemplate "the Mysteries," but when he or his handlers caught wind of how "cool" and mysterious Freemasonry was, and with books like Dan Brown's *The Lost Symbol* and films like *National Treasure*, the rapper thought he would attempt to attach himself to the mystique.

Baphomet

PHOTO: Eliphas Levi's 19th century depiction of Baphomet.

For those not familiar with Baphomet, I will briefly explain it here since many artists incorporate the

symbol into their videos or clothing. In his video for the song "Pirates," Rick Ross is shown sitting down on a large Baphomet throne. Rihanna wore a Baphomet looking headdress in her "Rock Star" video, and many people say Beyoncé's promotional material for *I Am...Sasha Fierce* (her alter ego) also used the symbol. Kanye West has worn shirts and even a skirt with the image on it, so what exactly is Baphomet and why are so many stars using the image?

Baphomet is basically an occult idol depicted as a goat's head or a half-man, half-goat figure that dates back to the ancient Knights Templar and the Crusades. Baphomet was the goat head that the Templars were accused of worshiping or using during their secret rituals.

The figure is the official symbol of the Church of Satan and is printed on the cover of *The Satanic Bible* overlaid on top of an upside down pentagram by making the upper two points of the pentagram form the horns of the goat with the bottom point forming its chin.

Another depiction comes in the form of a human-like winged goat resembling a gargoyle with breasts and a phallic serpent rising from its crotch. This popular image comes from an 1854 book written by a popular French occultist and ceremonial magician named Eliphas Levi.[101]

Satanists have a long tradition of adoring this bizarre figure. Eliphas Levi wrote, "According to some, the Baphomet was a monstrous head, but according to others, a demon in the form of a goat. A sculptured coffer was disinterred recently in the ruins of an old Commandery of the Temple, and antiquaries observed upon it a baphometic figure, corresponding by its

[101] Levi, Eliphas - *Transcendental Magic*

attributes to the goat of Mendes and the androgyne of Khunrath."[102]

Aleister Crowley wrote, "This serpent, Satan, is not the enemy of Man, be He who made Gods of our race, knowing Good and Evil; He bade "Know Thyself! and taught Initiation. He is "the Devil" of the book of Thoth, and His emblem is Baphomet, and Androgyne who is the hieroglyph of arcane perfection."[103]

It's interesting that many people claim the Catholic Church fabricated the stories of the Knights Templar being involved with Baphomet, but what's even more interesting is that famous occultists and Satanists admit the accusations were true!

"Did the Templars really adore Baphomet?" writes Eliphas Levi, in his 1854 book *Transcendental Magic.* "Did they offer a shameful salutation to the buttocks of the goat of Mendes? What was actually this secret and potent association which imperiled Church and State, and was thus destroyed unheard? Judge nothing lightly; they are guilty of a great crime; they have exposed to profane eyes the sanctuary of antique initiation. They have gathered again and have shared the fruits of the tree of knowledge, so they might become masters of the world."[104]

"Yes, in our profane conviction, the Grand Masters of the Order of the Templars worshipped the Baphomet, and caused it to be worshipped by their initiates," Levi declares.[105]

[102] Levi, Eliphas - *Transcendental Magic* page 316
[103] Crowley, Aleister – *Magick: In Theory and Practice* page 193
[104] Levi, Eliphas - *Transcendental Magic* p. 7-8
[105] Levi, Eliphas - *Transcendental Magic* p. 307

In *The Satanic Bible*, Baphomet appears on the list of list of Infernal Names, and is defined as a symbol of Satan that the Knights Templar worshiped.[106] Manly P. Hall reveals in *The Secret Teachings of All Ages* that, "The famous hermaphroditic Goat of Mendes was a composite creature formulated to symbolize this astral light. It is identical with Baphomet, the mystic pantheos of those disciples of ceremonial magic, the Templars, who probably obtained it from the Arabians."[107]

So it's no wonder we see so many musicians using the image in their videos, printed on their clothes or wearing jewelry encrusted with the figure. Most parents would recognize a satanic pentagram and it would cause them to take a closer look at the artists their children are watching, and even catch the attention of the mainstream press, but Baphomet is much more esoteric, and can slide under most people's radar.

The Pentagram

The upside down pentagram drawn inside a circle is one of the most familiar symbols of Satanism, and over the centuries various occult organizations have used it to represent spiritual power or dark forces. A pentagram is different from an ordinary five pointed star in that a pentagram consists of five straight lines that make up the points, which also form a *pentagon* in the center of the pentagram. Since the symbol is so well-known, most Illuminati puppets use more subtle symbols that are lesser

[106] Lavey, Anton – *The Satanic Bible* page 145
[107] Hall, Manly P. – *The Secret Teachings of All Ages* page 316

known to the public, like Baphomet, All-Seeing Eyes, Masonic checkerboard marble floors, owls, etc., but I will briefly explain the history and meaning of this popular illustration.

Early Christians used the five points of a (right-side up) pentagram or "pentalpha" to symbolize the five wounds of Jesus (the two spikes through his hands, two through his feet, and the spear that pierced his side). The design was later adopted by occultists and Satanists who flipped it upside down to deliberately "reverse" or pervert the design to signify their opposing views.

The Dictionary of Symbols entry on the figure reads, "As far back as in the days of Egyptian hieroglyphics a star pointing upwards signified 'rising upwards towards the point of origin' and formed part of such words as 'to bring up,' 'to educate,' and 'the teacher.' The inverted five-pointed star is a symbol of the infernal and used in black magic."[108]

33rd degree Mason Manly P. Hall confirms, "When used in black magic, the pentagram is called the 'sign of the cloven hoof,' or the footprint of the Devil. The star with two points upward is also called the 'Goat of Mendes,' because the inverted star is the same shape as a goat's head. When the upright star turns and the upper point falls to the bottom, it signifies the fall of the Morning Star." [109]

In Freemasonry, the pentagram is called the Blazing Star and represents the sun, Lucifer, carnal knowledge and power. To Wiccans and Pagans the five points of the star represent air, fire, water, Earth, and spirit.

[108] Cirlot, J.E. – *Dictionary of Symbols* p. 295
[109] Hall, Manly P. – *The Secret Teachings of All Ages* p. 327

Famous occultist Eliphas Levi explains, "The Pentagram, which in Gnostic schools is called the Blazing Star, is the sign of intellectual omnipotence and autocracy...The Pentagram with two points in the ascendant represents Satan as the goat of the Sabbath."[110]

Aspiring Rapper Shot Friend as "Illuminati Sacrifice"

The day after Christmas in 2012, a 27-year-old aspiring rapper in Virginia was arrested for shooting his friend, allegedly hoping to kill him as an "Illuminati sacrifice," believing it would get the attention of the Illuminati who would then reward him with a record contract and make him a famous rapper.[111]

The aspiring rapper, Wafeeq Sabir El-Amin, allegedly said, "You are my sacrifice," before he fired a shot at his friend's head, according to attorney Thomas L. Johnson.[112] The police report notes the victim was shot in the hand as he attempted to shield his face, and was able to take the gun from El-Amin and then shoot him in self-defense and escape.

Deputy Commonwealth's Attorney Thomas L. Johnson said the trial revolved around hip hop culture and the idea that the Illuminati controls successful rap artists. "It was the belief that a sacrifice had to occur in order to

[110] Levi, Eliphas – *Transcendental Magic* p. 237
[111] *Richmond Times-Dispatch* "June trial set for would-be rapper accused of malicious wounding" by Bill McKelway (March 15, 2013)
[112] Ibid

join the Illuminati that allegedly incited El-Amin," Johnson said.[113]

The aspiring rapper was stoned when the incident occurred and police found more than a pound of marijuana in his home while investigating the case, along with what was described as literature about the Illuminati and its alleged involvement in the music industry. El-Amin was also said to have been obsessed with rapper 50 Cent who famously survived getting shot nine times, an incident that largely helped propel his rap career. The deranged Illuminati wannabe El-Amin was found guilty of malicious wounding and sentenced to eight years in prison.[114]

Fifth Grader Claims Illuminati Membership and Threatens To Sacrifice Fellow Students to Satan

Even more bizarre than the 27-year-old aspiring rapper who shot his friend as an attempted "Illuminati sacrifice," is the story of a fifth grader (age 10 or 11) at a California elementary school who stood up in the middle of class shouting she was part of the Illuminati and threatened to kill other students as an apparent sacrifice to Satan.[115]

[113] Ibid

[114] *Richmond Times-Dispatch* "Henrico jury finds aspiring rapper guilty in shooting" by Liz Sawyer (June 27, 2013)

[115] *News 10 KXTV Sacramento* "Parents concerned after unusual outburst at south Sacramento school" (May 11, 2013)

"She said she wanted to sell her soul to the devil and she said she'll kill everybody," a fellow student told the local ABC affiliate KXTV.[116]

The Satan-obsessed student then grabbed a pair of scissors and started cutting herself and allegedly tried to stab another student. The local television news report on KXTV actually said the girl claimed to be in the Illuminati and other students reported she had drawn Illuminati symbols on the bathroom walls.

A parent of a fellow student contacted the local TV station after he felt the school didn't handle the situation properly since they didn't notify parents until 6:30 that evening and said his child was in tears when he picked her up from school that day. This parent believed the school was trying to sweep the incident under the rug and says they denied that a weapon had been involved. "There was a weapon involved. It was a pair of scissors," he said. "So it shocks me to see there are false statements in here knowing otherwise what happened at school yesterday."[117]

"Everybody just started crying because they were scared that they were going to die that day," another student told the news reporter.

"I seen her try to cut herself and draw blood, but then she got up and tried to stab another girl a seat away from her," another student said.

The Sacramento City Unified School District confirmed an incident happened at the school in an e-mail statement to KXTV News 10 written by Gabe Ross, SCUSC Chief Communications Officer, reading, "Authorities are investigating a disturbance inside a John

[116] Ibid
[117] Ibid

Sloat Elementary School classroom…The school responded immediately and all students were safe. Counseling and other resources have been made available to all John Sloat students today and will continue to be available as needed."

Was this mentally disturbed little girl a fan of Angel Haze, Azealia Banks, or Ke$ha, and influenced by them or other pop stars promoting Satanism and the Illuminati as cool?

Wal-Mart Illuminati Kidnapping Attempt

A 37-year-old man was shot and killed by police inside a Wal-Mart in Oklahoma in June 2013, after he snatched a two-year-old infant from her mom's shopping cart and held a knife to her neck saying he was going to kill her for the Illuminati. [118] The psycho, Sammie Wallace, was an African American male, and most likely a Rick Ross and Jay-Z fan who wanted to be a part of the Illuminati, and like other delusional dirt bags, thought he had to sacrifice a person to Satan in order to receive his reward.

When this story first started circulating on the Internet, many people thought it was a hoax because it was so bizarre, but the incident actually happened, and the local Oklahoma TV station News 9 reported, "According to an affidavit for a search warrant, Wallace began

[118] News9.com "Suspect Mentioned Satanic Cult While Holding Toddler Hostage At MWC Walmart" (Jun 19, 2013)

speaking about the Illuminati, a satanic cult, while holding the girl and pointing a knife at her. Police say they quickly did some research and learned June 21 is a day of human sacrifice for the Illuminati."[119]

After police searched Sammie Wallace's house, they reported they found a notebook containing "religious writings." When the Illuminati-obsessed sicko started counting down, claiming he would kill the child when he got to zero, police captain David Huff fired a single shot, killing Wallace. Thankfully the child was unharmed during the incident.

Angel Haze

PHOTO: A still from Angel Haze's "Werkin Girls" video where a group of Illuminati thugs kidnap a group of children.

An anorexic-looking, scrawny, sickly appearing rapping rat named Angel Haze tried to push the envelope into uncharted evil territory with the release of her music video "Working Girls" (styled *Werkin Girls*) by having a

[119] Ibid

gang of Illuminati thugs kidnap a bunch of young children while she stands by watching in apparent delight and rapping about what a badass she is.

The children, who appear to be aged 6 to 8, are shown playing jump rope in the video when several masked thugs approach and violently sweep them away. The screen flashes a close-up of a tattoo on one of the perpetrators' arms which clearly shows it's an Illuminati All-Seeing Eye with a snake wrapped around it. The song has no point other than to serve as a self-promotion platform for Haze and she appears to simply stand by watching the children getting snatched as if she thinks it's cool, or is perhaps in cahoots with the kidnappers.

To make it even worse, this witch is wearing a large crucifix around her neck throughout the video. Angel Haze grew up in with a family involved with the Greater Apostolic Faith, which she describes as a cult, and may explain her rebelling against what is good, and "turning to the dark side," so to speak, by being involved in such a filthy music video and rap persona.

At the time of this writing Angel Haze is not a mainstream artist or a household name, but that is undoubtedly her goal, and she is waiting in the wings, signed to Universal Music Group, one day hoping to be chosen as the next Illuminati idol to roll out to the world.

Azealia Banks

PHOTO: A still from Azealia Bank's video "Young Rapunzel" showing her rap in front of an All-Seeing Eye on the wall.

Another babbling brainless bisexual bimbo who jumped on the Illuminati bandwagon is female rapper Azealia Banks with her music video "Young Rapunzel," stylized *Yung Rapunxel*. Banks, who sounds like a man, appears on screen with an owl flying out of a hole in her forehead—the owl, of course, a symbol of the Bohemian Grove and the same mascot adopted by rapper Drake, the feminine fool who dances like an epileptic having a seizure.

Of course, Azelia Banks is shown rapping in front of a huge pyramid with an All-Seeing Eye painted on the wall behind her, and there's a scene of her riding a bull reminiscent of the *Book of Revelation* where the Whore of Babylon is described as riding a beast.[120] Then of course there are several scenes of Banks bashing a police officer over the head with a bottle in an attempt to look tuff.

This trendy piece of trash thinks she's a hard core ho, but she's simply another wanker in a growing list of

[120] *Revelation* chapter 17

obvious Illuminati wannabes. This singing serpent is spreading proverbial syphilis with her stupid songs, and is simply just another satanic skank who sold her soul to Satan hoping for fame and wealth, but in reality she has no talent, her delivery is disastrously dumb, and she brings nothing new to the artistic table. Someone should have told this fame whore that just because it worked for Rihanna, Jay-Z, Rick Ross, Kanye West and Ke$ha, it wouldn't necessarily work for her since she's a little bit too late and comes off as simply a pathetic Illuminati posing Johnny Come Lately copycat trying too hard to be cool, not to mention, she sounds like a man. Or maybe she is. I don't really want to know.

Apparently Azealia Banks used some samples for an upcoming single before obtaining the rights from the actual producer and after her legal team reached out to him and offered him $25,000 for the rights, he turned it down and said, "I don't want your fucking $25,000. Fuck off. Go be a puppet bitch to someone else."[121]

[121] *HopHopDX* "Azealia Banks Pulls New Single After Producer Denies Permission" by Sean Ryon (September 25, 2012)

Tupac Shakur

Tupac Shakur, who was shot and killed in a Las Vegas drive-by shooting in 1996 and considered one of the greatest rappers of all time, recorded an album shortly before his death titled *The Don KIlluminati: The 7 Day Theory* which remains the topic of speculation among his fans who think the title was a reference to exposing the Illuminati. "The Don" is a mafia term for a mafia boss or leader, which makes some of Tupac's fans think that he had learned about the Illuminati and titled his album this as a coded message meaning he was the leader of the killers of the Illuminati.

Many people believe the Illuminati orchestrated his murder to silence him since in his music and interviews he often sent a positive and empowering message of love, peace, and encouraged education instead of the typical gangster rap garbage we are all too familiar with. Senator Marco Rubio of Florida was asked about his opinion on Lil Wayne once comparing himself to Tupac, and answered, "There is only one Tupac...These guys have some message in what they're saying, but I think they're largely entertainers. I think Tupac was more someone who was trying to inform us about what was going on, and he did it through entertainment."[122]

The paparazzi videographer who worked for TMZ voiced surprise, and Rubio continued, "Tupac is someone I listened to growing up, and he was a complicated person. He wasn't perfect, that's for sure. He made a lot of mistakes, but I think he was very honest in his music and

[122] *TMZ* "Senator Marco Rubio: Lil Wayne Ain't No Tupac" (2-26-13)

gave us insight into a time in our country and really gave a voice to a people in America at that time who were facing different struggles...He made a lot of mistakes, that's for sure, but he was very real in a way you don't see today."[123]
"Today," Rubio said, "It's all about money or how much he's making. Tupac actually grew up. Every year that went by, his music got deeper and more introspective...Lil Wayne isn't putting anything out there like that."

Tupac was definitely using his music to raise awareness about important social issues like racism, drug abuse, violence, and the value of an education, but was he trying to expose the Illuminati too? Many of his fans believe this, but will be very disappointed when they learn of a little known interview he gave about this very subject and the meaning of his term "Killuminati."

In the course of their discussion when the interviewer mentions the Illuminati, Tupac responds, "Niggas is telling me about this Illuminati shit while I'm in jail, right, like you gotta listen to all this. That's another way for them to keep your self-esteem low! That's another way to keep you unconfident. And I'm putting a "k" cuz I'm killing that Illuminati shit! Trust me. If these mother fuckers wanted to kill you, why the fuck would they tell [Louis] Farrakhan? Why are they going to tell the Nation of Islam? Why are they gonna tell this nigga in jail about the plan? How did he know? How'd it leak to him? Who told him? The Pope? Who? Cuz they like, the Pope and the money, awe come on man, get the fuck out of here."[124]

[123] Ibid
[124] *YouTube* "2pac Talks about the Illuminati (He Did Not Believe)"

While Tupac was said to be an avid reader, he really missed the boat on this one, because there were plenty of books available while he was alive that detailed the history of the Illuminati and the evidence of its continued existence. For example in 1986, ten years before Tupac's death, Antony Sutton released *America's Secret Establishment*, detailing how the Skull and Bones society was created in 1832 as an extension of the Illuminati and how the Bilderberg Group, the Council on Foreign Relations, and the Federal Reserve banking cartel all function as the superclass ruling elite and modern day Illuminati front groups.

There were many other popular books available during Tupac's time such as *None Dare Call it Conspiracy* (1971), *Occult Theocrasy* (1933), *Secret Societies and Subversive Movements*, (1924), and even John Robison's classic *Proofs of a Conspiracy,* published in 1798 and still in print today, which was one of the first English translations of the original writings of Adam Weishaupt that were discovered in 1786 by local authorities.

Gunplay

PHOTO: Gunplay's mug shot in October 2012 after an an arrest for armed robbery with a firearm.

A rapper who goes by the name of Gunplay (real name Richard Morales Jr.) is another interesting case of a rapper whose life imitates his art because of his run-ins with the law, and who has also talked about the Illuminati in interviews, although he's not exactly a good example of someone who is fighting to expose them and make the world a better place.

Gunplay, as his name suggests, likes to play with guns, and in October 2012 he was arrested for armed robbery and aggravated assault after a videotape from a security camera showed what looked like him pistol whipping his accountant and then stealing his chain.[125] The charges were later dropped when the accountant, Turron Woodside, refused to testify.[126]

Gunplay started his career by joining (the fake) Rick Ross's southern hip hop group the Tripple C's (Carol

[125] *TMZ* "Gunplay PULLS GUN on Accountant ... CAUGHT ON TAPE" (10-13- 2012)

[126] *Miami.cbslocal.com* "Armed Robbery Charges Dropped Against Miami Rapper Gunplay" (2-25-2013)

City Cartel), and signed to (the fake) Rick Ross's Maybach Music Group label. He is basically yet another unoriginal gangster rapper trying to cash in on the genre as another one of countless cookie cutter copies.

In December 2012 Gunplay tweeted about the Sandy Hook Elementary School massacre insinuating it was a government run false flag conspiracy, but later deleted the tweets.[127] "Government killed dem kids to take our guns away. Another 9/11. Don't get it twisted," he tweeted to his 100,000 or so followers at the time. "Ya'll are sheeple 4 thinking da government ain't gotta hand in every crisis since the great depression."[128]

In an interview with Vice in 2012 the rapper brought up the Bilderberg Group and the Illuminati, saying, "They control everything. Everything. From wars to weather, everything. It gets real deep, man. That's one of those things I try to fill my head with knowledge about. Who are the puppet masters? You stumble on one thing, you stumble on another thing, and you just open up a can of worms. You try to tell everybody, but they're looking at you like, 'What?'"[129]

Gunplay was asked if he thought there were any rappers in the Illuminati, to which he gave a surprisingly accurate answer of basically "no," and went on to explain, "All you can do is inform yourself, because you can't do nothing about it. I don't think no man should have that much control, but it is what it is. It's a grim reality. Embrace it, and inform people of what's going on.

[127] *XXL Magazine* "Rapper Gunplay Tweets That Sandy Hook Shooting Was Gov't Conspiracy To 'Take Our Guns Away'" by Andrew Kirell (December 26th, 2012)
[128] Ibid
[129] *Vice.com* "Gunplay Taught Me About The Secret World Government" by Drew Millard (Jul 2, 2012)

That's the only thing you can do…It's already too late, because we're already programmed on the channel they want us to be on. It is what it is. You just gotta embrace it and inform the public. Inform the people. Inform the ones you love because it's going down."[130]

Unfortunately, Gunplay doesn't realize that he's part of the problem and a seemingly willing servant of this socially enslaving system by appearing to offer himself up as an icon of evil in exchange for money and fame.

Dwight York

A black supremacist and convicted child molester sentenced to 135 years in prison for having committed one of the largest numbers of abuses, was a very influential spiritual teacher for several famous musicians before he was sent to prison. Dwight York is said to have inspired several popular musicians with his brand of black supremacist occultism called Nuwaubianism, which comes from the Arabic word "nubuwa" which means prophet hood or prophesy.

York was a singer and music producer in Brooklyn before he left New York in 1993, moving to Georgia. His birthdate is unclear, but is believed to be in 1945 or 1935, and he went by a long list of pseudonyms over the years, including Malachi Z York, Issa Al Haadi Al Mahdi, and Dr. York. In the 1990s he built an enormous Egyptian-themed compound on 476 acres in Eatonton, Georgia called Tama-Re for his hundreds of followers. After his conviction in 2004 of child abuse, the

[130] Ibid

government acquired the property through asset forfeiture and demolished it.

Author Bill Osinski, reported "When he was finally indicted, state prosecutors literally had to cut back the number of counts listed—from well beyond a thousand to slightly more than 200—because they feared a jury simply wouldn't believe the magnitude of York's evil…. [It] is believed to be the nation's largest child molestation prosecution ever directed at a single person, in terms of number of victims and number of alleged criminal acts."[131]

Many people believe Dwight York was practicing a very perverted and evil form of Sex Magick (spelled with a "k" on the end as stylized by Satanist Aleister Crowley) in which some people believe they obtain magic powers by sexually abusing children. Considering York's involvement in fringe occult philosophies and his conviction of child abuse, he may very well have been engaging in this kind of despicable behavior with children. Some of York's supporters have claimed he was set up and framed by the government, and insist he is innocent.

[131] Osinski, Bill - *UnGodly: A True Story of Unprecedented Evil* (2007)

Prodigy

Prodigy is a rapper and member of the duo Mobb Deep, who released his second solo album *H.N.I.C.2.* in 2008, that included a song titled "Illuminati," telling the evils of this secret society and includes a chorus saying, "Illuminati want my mind, soul, and my body...Secret society trying to keep their eye on me."

While in prison for illegally possessing a weapon, he penned a five page letter about the Illuminati and the music industry, saying, in part, "Jay-Z and Jaz-O were both raised (in their teenage years) in Dr. [Dwight] York's 'Nuwabian' community in Bushwick Brooklyn...Jay-Z knows the truth, but he chose sides with evil in order to be accepted in the corporate world and promotes the lifestyle of the beast instead...Jay-Z is a God damn lie. I have so much fire in my heart that I will relentlessly attack Jay-Z, Illuminati, and every other evil that exist until my lights are out...I have been empowered by God and the Universe."[132]

He goes on to write about a negative energy many mainstream rappers are playing with, saying, "This negative energy is created and harnessed by the Illuminati secret government and they will make you spread this energy without even knowing it but people like Jay-Z are very well aware. He was schooled by Dr. York so if you are aware and still spread it, what does that make you? Who and what do you represent? I'm not saying these bad things about Jay-Z cuz we had a rap beef...Jay-Z is

[132] *ThisIs50.com* "Letter from the Pen: Prodigy Takes Shots at Rell, Rick Ross, and Names His Favorite 40 MC's" (March 8, 2009)

not the only 'aware' rapper that sided with evil, but he's the most influential."[133]

During the 2008 presidential campaign when practically every African American entertainer was thrilled that Barack Obama was running for president, Prodigy called him a phony and a plastic president. "I wish nothing but love and happiness for him, but he's either gonna be assassinated to create chaos and bring about martial law or he'll live and then years down the line, at the end of his term everybody will see that he's just like the rest of these plastic presidents, who does absolutely nothing good. Just another puppet for the Royal family."[134]

Prodigy also publicly voiced support for Congressman Ron Paul (R-Texas) who was running for president that year (and again in 2012). Because of his pro-Constitution principles and consistent track record, Ron Paul was a favorite for many Americans who see the Illuminati as a threat to our liberties, economy, privacy, and even our planet.

Prodigy believes that Dwight York was set up and framed by the Illuminati when he was sentence to 135 years in prison for an enormous number of child abuse cases. Prodigy is most likely in denial since he looked up to York and saw him as an enlightened spiritual teacher. As I'm sure you are well aware, many times the family members and close friends of people who commit heinous crimes cannot come to grips that someone they were so close to could be so evil, so as a psychological protective

[133] Ibid
[134] *BallerStatus.com* "Prodigy Calls Obama 'A Phony' And 'A Puppet'" by Allen Starbury and Rohit Loomba (June 5, 2008)

mechanism they simply cannot believe the person actually did those things.[135]

Professor Griff

PHOTO: Professor Griff's book cover, *The Psychological Covert War on Hip Hop.*

One of the most vocal musicians against the Illuminati in the music industry is Professor Griff, formerly of the rap group Public Enemy. Griff committed the entertainment industry cardinal sin when during a 1989 interview with David Mills of *The*

[135] *PsychCentral.com* "Denial is the refusal to accept reality or fact, acting as if a painful event, thought or feeling did not exist. It is considered one of the most primitive of the defense mechanisms because it is characteristic of early childhood development."

Washington Times he reportedly made several anti-Semitic statements, including allegedly that "Jews are responsible for the majority of the wickedness in the world."[136] Griff insisted his statement was taken out of context and audio of the interview was never released for people to hear it in its entirety.

Professor Griff was fired from Public Enemy over the controversy caused by the interview and later issued an apology and met with Jewish groups trying to make amends. In his 2009 book, titled *Analytixz*, Griff explained, "To say the Jews are responsible for the majority of wickedness that went on around the globe, I would have to know about the majority of wickedness that went on around the globe, which is impossible...I'm not the best knower—[God] is. Then, not only knowing that, I would have to know who is at the crux of all of the problems in the world and then blame Jewish people, which is not correct."[137]

Griff later embraced a form of Afrocentrism and formed a music group called the Last Asiatic Disciples that rapped about the New World Order and various conspiracies.

[136] *LA Weekly* "The Shit Storm" by Robert Christgau (1989)

[137] Professor Griff. *Analytixz: 20 Years of Conversations and Enter-views with Public Enemy's Minister of Information.* Atlanta: RATHSI Publishing, 2009, p. 12

J. Cole

Years after selling Roc-A-Fella Records to Def Jam, Jay-Z started another label called Roc Nation, and the first artist signed after it was launched was J. Cole, whose debut album *Cole World: The Sideline Story* came out in 2011, earning him a nomination for Best New Artist at the Grammys that year.[138]

During an interview with Hot 93.7 in Hartford, Connecticut, Cole was asked about the Illuminati rumors swirling around his boss Jay-Z.

"You know what's crazy, before I got a deal and became part of the industry, I was one of those people. I was a conspiracy theorist. There were times I would look at those videos like 'Jay-Z's a member of the Illuminati!' and I would be like 'Ooooohhhhh!' And then you meet him, and you see how things work, and that's bogus—that's somebody that's so far from the truth in what's actually happening, just creating something. They're probably high. It's not true."[139]

On his 2013 Album *Born Sinner*, the first track is titled "Villumanati," meaning the Fayetteville Illuminati, a reference to Fayetteville, North Carolina, where he grew up. On the track he raps, "Fuck everybody. I'm about to go and join the Illuminati. This next three bars is dedicated to the retards [who] keep asking me about the Illuminati. Is you stupid nigga? Young black millionaire, all white billionaires, I'm sure that they can

[138] *LA Times* "J. Cole gets off sidelines with album, Grammy nomination" (December 19, 2011)
[139] *Hot 93.7* "J. Cole Talks The 'Illuminati' & Who He's Crushing On" (April 9, 2013)

do without me. And I ain't really into sacrificing human bodies."[140]

The statement about sacrificing human bodies is likely a reference to the Cremation of Care at the Bohemian Grove, something more and more people have become aware of from YouTube and social media, and since J. Cole said he used to watch "conspiracy" videos, he is probably aware of some of the activities and allegations surrounding the Bohemian Grove.

Jay Electronica

Another rapper signed to Jay-Z's Roc Nation record label with some interesting ties is Jay Electronica,[141] whose connection to the Illuminati is beyond simply using occult symbols or name-dropping them in a song. While in a relationship with his baby's momma, Erykah Badu, this clown was reportedly having an affair with Kate Rothschild, a member of the notorious Illuminati banking family. Kate's blue blood multi-millionaire husband Ben Goldsmith filed for a divorce from her citing adultery after he allegedly discovered her having a yearlong affair with Electronica.[142]

Kate Rothschild inherited tens of millions of dollars from her father, banker Amschel Rothschild, after he committed suicide by hanging himself in his Bristol

[140] J. Cole "Villuminati" track on *Born Sinner* album (2013)

[141] *HipHopDX* "Jay-Z Signs Jay Electronica To Roc Nation" by Omar Burgess (November 13, 2010)

[142] *Daily Mail* "Rothschild heiress's marriage to Goldsmith scion is over... after she falls for a rapper called Jay Electronica" by Katie Nicholl (June 2nd 2012)

Hotel room in Paris in 1996.[143] The death was initially reported as the result of a heart attack, but was later confirmed a suicide by relatives refusing to discuss the details.[144] He was the chairman of Rothschild Asset Management.

The heiress Kate later started her own record company called Round Table records and that's how she met Jay Electronica. Her company's name, "Round Table," is a reference to the British round table secret societies and elitist organizations set up by the likes of Cecil Rhodes, who wrote in his will that his money must be used to fund a secret society called the Round Table Group, with the goal of maintaining the Illuminati controlled British Empire around the world.

His last will and testament literally reads, "To and for the establishment, promotion and development of a Secret Society, the true aim and object whereof shall be for the extension of British rule throughout the world, the perfecting of a system of emigration from the United Kingdom, and of colonization by British subjects of all lands where the means of livelihood are attainable by energy, labor and enterprise, and especially the occupation by British settlers of the entire Continent of Africa, the Holy Land, the Valley of the Euphrates, the Islands of Cyprus and Candia, the whole of South America, the Islands of the Pacific not heretofore possessed by Great Britain, the whole of the Malay Archipelago, the seaboard of China and Japan, the ultimate recovery of the United States of America as an

[143] *The Independent* "Obituaries: Amschel Rothschild" byJames Fergusson (July 11th 1996)
[144] *New York Times* "Rothschild Bank Confirms Death of Heir, 41, as Suicide" by Yousseff M. Ibrahim (July 12, 1996)

integral part of the British Empire, the inauguration of a system of Colonial representation in the Imperial Parliament which may tend to weld together the disjointed members of the Empire and, finally, the foundation of so great a Power as to render wars impossible, and promote the best interests of humanity."[145]

Cecil Rhodes, this Round Table Group creator, was a British born businessman who moved to Africa to start the DeBeers diamond monopoly, and with the help of Edward Bernays, the public relations genius, he brainwashed millions of men and women around the world into believing they need to own large diamond rings, necklaces, and ear rings in order to feel loved, while the inventory of the stones is purposefully suppressed to artificially inflate the prices. This same diamond monopoly man also created the Rhodes Scholarships which are given to college students who the Secret Establishment sees as likely participants in their New World Order plan, and are used to groom young men and women by introducing them to the Invisible Empire. President Bill Clinton is one of the most well-known recipients of this scholarship, who mysteriously rose to power from obscurity with the help of this hidden hand.[146]

So in a world of Illuminati posers and puppets, it is interesting, at the very least, that Jay Electronica allegedly had a yearlong sexual relationship with a member of the notorious Rothschild banking family, literally, according to various reports, getting in bed with a supposed Illuminati family member. The rapper tweeted some

[145] Rotberg, The Founder, pp. 101, 102. & Niall Ferguson, The House of Rothschild: The World's Banker, 1848–1998, Penguin Books, 2000

[146] http://www.whitehouse.gov/about/presidents/williamjclinton

threats to Ben Goldsmith, his alleged mistress's husband, after news reports were first published about Kate Rothschild's alleged affair with the rapper, saying he would "come see" Goldsmith if he didn't shut his mouth.[147]

Several reports have stated that Jay Electronica's album *Act II – The Patents of Nobility* would contain a track titled "New Illuminati" that featured none other than Kanye West,[148] due to his unprecedented Illuminati posing. At the time of this writing, his album had been in the works for years but was faced with repeated delays and will supposedly be released soon.

[147] *SOHH.com* "Jay Electronica Threatens Billionaire" by Cyrus Langhorne (June 22, 2012)

[148] *XXL Magazine* "Jay Electronica's Album to Feature Jay-Z, Kanye West and Diddy" by mlelinwalla (July 30th 2012)

The Game

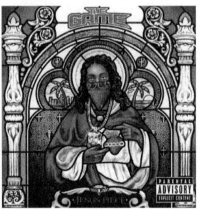

PHOTO: The Game's album cover *Jesus Piece,*
depicting Jesus as a gang member.

The Los Angeles based rapper who goes by "The Game" (a really lame name, I know) was interviewed by a conspiracy website called Truth is Scary and when asked about the Illuminati, he stood up out of his chair and said, "I can't talk about that."[149] He also said the world was going to end at the end of 2012, while trying to sound serious and sophisticated.

The Game is just another wannabe LA gangster in hip hop who's made headlines for his unhealthy relationships and his habit of fighting.[150] He is probably best known for his hideous "LA" face tattoo on his right cheek, which is actually a cover up of a previous tattoo of a butterfly that he bizarrely inked on the same spot. As if

[149] *YouTube* Interview "The Game won't talk Illuminati & Says We Are All Going to Die in 2012" (Uploaded Aug 22, 2011)
[150] *TMZ* "The Game Booted From Lil Wayne's Bday After Club Brawl" (9-29-2012)

this wasn't dumb enough, a few years later he got a huge tattoo of President Obama on his chest![151]

Just two weeks after the Sandy Hook Elementary School massacre, when 20-year-old Adam Lanza killed twenty children and six adults in Sandy Hook, Connecticut and the entire country was mourning, The Game released a song titled "Dead People," where the entire track was basically about stalking and murdering people for fun because he's a psycho. The track is on an album called *Jesus Piece*, a slang term for a gang banger's favorite gun, and the cover art depicts Jesus as a member of the Bloods street gang.[152]

> Ski mask, body bag, duct tape, and a pillow
> In the front solo
> Sittin' low with the lights out
> Feelin' like Manson on some Son of Sam shit
> With a murder on my mind and my mind on a homicide
> *-Dead People*

[151] *EOnline.com* "Rapper Game Gets Barack Obama Tattoo" by Bruna Nessif (March 13, 2013)
[152] *FoxNews.com* "Rapper The Game's gangbanger Jesus CD cover offends some Christians" by Hollie McKay (December 14, 2012)

T-Pain

T-Pain, the King of Auto-Tune, the guy who made mainstream music even more unbearable to listen to than it already was, joked about hoping to join the Illuminati so he could make more money after his career had stalled. Because his Auto-Tune gimmick got overplayed and he fell off the face of the earth, in desperation he once said, "Boy, if there is an Illuminati, I'm looking for them. I'm telling you boy, I'm down to get in it, cuz I would be way richer than I am right now."[153]

While it appears he was joking or saying such things in jest, his statements reveal how appealing the Illuminati is to those who lust after fame and money, and also shows how more and more people are associating the Illuminati with the puppet masters who pull the purse strings and decide who will be chosen to be advertised and promoted in the corporate media.

Of course the zombie masses loved T-Pain and his trademarked Auto-Tune novelty gimmick for a season, but his fifteen minutes of fame ticked away rather fast, and the masses moved on to the next trend and technological bread and circus, looking for something new to satisfy their itching ears.

[153] *Power 106 FM* "Big Boy's Neighborhood"

A$AP Rocky

PHOTO: A still from A$AP Rocky's video "Wassup" showing a satanic pentagram on the floor during a party.

Another talentless rapper waiting in the wings hoping to be chosen as the next token act propelled through the mainstream media pipeline is A$AP Rocky, who's another jive turkey talking gibberish marketed as music. In a blatant attempt trying to get noticed, he released a music video for his song "Wassup" that began by showing a huge three-foot-wide satanic pentagram on the floor, looking like it was made out of cocaine, and featured your typical scantily clad women shaking their booties and guys drinking 40's while showing off handfuls of cash.

What most viewers don't understand is that the stacks of cash often seen in music videos come from the prop department, not the bank, and are just as fake as the rappers who flash it. Many of the cars,[154] jewelry,[155]

[154] *TrendHunter.com* "50 Cent Busted For Fibs About Ferrari Collection" (Nov 19, 2007)

and even the homes themselves featured in MTV's hit show *MTV Cribs*, were often rented by the artist to show off in their segment.[156]

During an interview with Jazzy T at 93.7 WBLK in Buffalo, A$AP said, "I wish I was Illuminati. Show me Illuminati," as he enthusiastically expressed his admiration for the group and his desire to be "in" with them so he could make some money and get famous.[157] The fact that so many rappers literally say they would love to join the Illuminati shows how they are willing to sell out to the corrupt corporate system and do anything in exchange for fame and fortune.

[155] *Rap Basement* "50 With Rick Ross Baby Momma 'His Jewelry Is Rented' (February 2, 2009)
[156] *YouTube* "Ameer Records Own The Phantom Donk"
[157] *93.7 WBLK* "A$AP Rocky Talks Illuminati & God" (March 11, 2013)

Eminem

PHOTO: Eminem posted this picture on his Twitter showing him throwing up Devil horns and the All-Seeing Eye.

Marshall Mathers, aka Slim Shady, aka Eminem, skyrocketed to superstardom beginning in 1999, becoming one of the most famous rappers of all time after getting signed to Dr. Dre's Aftermath Entertainment music label, a subsidiary of Interscope records. It wasn't just being white that fueled his celebrity, but rather his extremely violent and vile lyrical content, including songs about doing drugs, [158] raping women, [159] doing a Columbine-style school shooting, [160] and even killing his

[158] *Role* Model from Slim Shady LP
[159] *Salon.com* "Eminem's dirty secrets" by M.L. Elrick (July 25th 2000)
[160] *I'm Back* - Track 10 on The Marshall Mathers LP

baby's momma.[161] Instead of the mainstream media being repulsed and not giving him a national platform, Eminem instantly became one of their favorite friends and most famous celebrities in the world, loved largely by children who couldn't get enough of him. Countless girls even worshiped him, despite his misogynistic message, and they too loved to sing along to his sick songs.

During Eminem's time in the limelight, various gruesome crimes were committed by his fans that were believed by some to be acting out the scenarios depicted in several of his songs. In one incident a twenty-one-year-old Eminem impersonator named Christopher Duncan murdered his girlfriend after singing Eminem songs at a karaoke bar by beating her unconscious and then stuffing her in a suitcase where she then suffocated.[162] The song "Kim" depicts Eminem killing his girlfriend with lyrics like, "Don't you get it bitch, no one can hear you! Now shut the fuck up and get what's coming to you! You were supposed to love me! [Kim choking] NOW BLEED! BITCH BLEED!"

A fourteen-year-old boy in Peterborough, Ontario was charged with murdering his own mother and burying her body in the backyard, allegedly modeling the murder after Eminem's music video "Cleaning out My Closet," which in court was said to be the boy's favorite song, that depicts Eminem murdering his mother and burying her body in the backyard.[163]

[161] *Kim* from The Marshall Mathers LP
[162] *Daily Record (Scotland)* 'EMINEM' KILLER' Fan murdered student after she fell for him as he sang rapper's hits at karaoke night" by Richard Elias (December 2, 2005)
[163] *Toronto Star* "Murder mimicked favorite lyrics, trial told" by Carola Vyhnak (November 5, 2009)

A twelve-year-old boy was convicted of indecent assault after he was allegedly inspired by an Eminem song to force a nine-year-old boy to perform a lewd sex act on him.[164] The Eminem track "Ken Kaniff," which is a short skit included on Eminem's album, "The Marshall Mathers LP," was played in court during the case. Prosecutor William Baker said that, "One possibility is that the twelve-year-old boy in adolescence heard the track and thought it would be a good idea to make someone do that to him," referring to the lewd act depicted in the song.[165]

Michele Elliott, director of Kidscape, a child protection charity, commented on the case, saying, "There is something disturbing about a record or video egging people on to behave outside social parameters. I personally find them disgusting and don't think we should give them a platform. If you are already disturbed, listening to something particularly unpleasant could give you the rationale that it is okay."[166]

A few years after the pinnacle of his time in the limelight, Eminem released a music video about the 2004 presidential election for his song titled "Mosh," which was a scathing attack against President George W. Bush and his fear mongering surrounding the War on Terror. The video starts with a parody of George W. Bush reading *My Pet Goat* to a classroom of children as a jet flies over the school and crashes into the World Trade Center. It then cuts to Eminem standing in front of a wall covered with newspaper clippings and headlines about Bush's

[164] *News.telegraph.co.UK* "Eminem lyrics are blamed for sex attack" by Nigel Bunyan (8-29-2002)
[165] Ibid
[166] Ibid

foreknowledge of the 9/11 attacks, including the *New York Post's* famous front page headline, "Bush Knew."

Eminem roars, "Look in his eyes it's all lies!" as President Bush is shown on the screen, and then the video moves to a cardboard cutout of Osama Bin Laden on a soundstage controlled by then Secretary of Defense Donald Rumsfeld and Vice President Dick Cheney. Eminem goes on to rally dozens of people who surround the Capitol building in Washington DC and head up the stairs, pouring inside in what appears to be the beginning of a riot, when it is revealed they are all actually lining up to vote. The song itself is extremely powerful and the music video, which was produced by the *Guerilla News Network,* presented a powerfully positive message about activism and strength in numbers.

Despite this powerful and positive song, Eminem is still a pawn of the Illuminati and was promoted by the Illuminati controlled mainstream media as a role model for the youth because the vast majority of his music preaches violence, immorality, and irresponsibility. This popular and surprisingly powerful song only served as bait to attract more people to his poison since the overwhelmingly majority of his music is pure mentally enslaving mind control. In practically every one of his songs he sounds like an angry teenager screaming about being grounded by his parents and lashing out at the world in angst.

It's important to note that the key to Eminem's success was rapper and producer Dr. Dre, who is considered one of the founding fathers of gangster rap because of his membership in the group NWA (Nigga's With Attitude), and who is credited with discovering Eminem and launching his career. Dr. Dre entered into the mainstream limelight with his debut solo album *The*

Chronic in 1992, which featured a pot leaf on the face of the CD. After Dr. Dre heard one of Eminem's demo tapes, he immediately gave him a record deal recognizing the marketing appeal of a white rapper from Detroit. Some find it ironic that Dre made a career out of promoting alcohol, drugs, and thugs when his 20-year-old son Andre Young Jr., would later die of a drug overdose in 2008.[167] While some call it a tragedy, others have called it Karma or say Dr. Dre reaped what he had sowed.

I take seven (kids) from (Columbine),
stand 'em all in line
Add an AK-47, a revolver, a nine
a Mack-11 and it oughta solve the problem of mine
and that's a whole school of bullies shot up all at one time
Cause (I'mmmm) Shady, they call me as crazy
-I'm Back

[167] *Los Angeles Times* "Son of rap producer Dr. Dre found dead; Andre Young Jr. was 20" by Andrew Blankstein and Chris Lee (August 26, 2008)

Suge Knight

PHOTO: Suge Knight's mug shot from one of his many arrests.

While this is a book mainly about Illuminati puppets, fake gangsters and posers (nonetheless still real pieces of garbage), one man in the music industry who doesn't need to pretend to be a gangster is Suge Knight, the founder and former CEO of Death Row Records. In the 1990s Suge was one of the most feared men in the music industry, standing 6 foot 4, weighing 265 pounds, and having a long history of violent encounters.

Suge produced albums for Tupac Shakur, Dr. Dre, Snoop Dog and other chart-topping acts, but after a series of financial and legal problems he slowly faded from popularity, occasionally making headlines for his latest run-ins with the law. He is perhaps best known for driving the car that Tupac was killed in when he became a victim of a drive-by shooting in 1996, which remains unsolved and the topic of much speculation about who killed him and why.[168]

[168] *CBS Los Angeles* "Ex-LAPD Detective Says He Knows Who Killed Tupac, Biggie Smalls" (October 8, 2011)

Suge's run-ins with the law are legendary, so here's just a sample of his rap sheet. In 1992 he was put on probation after a weapons and assault charge and found guilty of violating that probation in 1996 for an altercation in the MGM Grand Hotel in Las Vegas after security cameras showed him involved in another assault, resulting in him being sentenced to nine years in prison. He was released in 2001 after four years on the condition that he would not have any contact with Dr. Dre.

In December 2002, he was arrested again and did two months in jail for violating his parole by associating with known gang members.[169] The following year in June of 2003, Suge was arrested again after assaulting a parking lot attendant at a club in Los Angeles and sentenced to another ten months in prison.[170] In February 2005, police found marijuana in his car after pulling him over for an illegal U-turn and kept him in jail for a week, but the marijuana charges were dropped, most likely because his lawyers successfully argued one of his friends must have stashed the weed there without his knowledge. That same year Knight was shot in the leg during an altercation at a Miami Beach night club. He refused to cooperate with police and no one was charged with the shooting.

Knight was arrested again in Las Vegas in 2008, for aggravated assault and drug charges after allegedly assaulting Melissa Isaac, his girlfriend of three years, and brandishing a knife.[171] The charges were dropped when

[169] *The Smoking Gun* "Suge Knight Back In The Can" (December 1, 2002)
[170] *Washington Post* "Like Knight and Day?" by Teresa Wiltz (June 17, 2007)
[171] *Las Vegas Sun* "Cops' case against 'Suge' Knight stalled" by Abigail Goldman (Oct. 31, 2008)

police could not find Melissa, who was mostly likely afraid to cooperate with authorities fearing the repercussions from Knight if she did.[172] The following year Knight was a suspect in the robbery of a record producer named Noel "Detail" Fisher after five armed men broke into his house, stole $170,000 worth of jewelry and a locked safe, allegedly claiming they were collecting a debt on behalf of Knight.[173]

In May 2013, a photo of a black BMW with the word "Illuminati" affixed in place of the BMW logo on the rear of the trunk was posted online by a girl who said her boyfriend "swears it was Suge Knight driving the car." The photo was said to have been taken in Hollywood. Others point out that the BMW was several years old and say Suge wouldn't be driving such an "old" car, and insist it was just someone who looked like Suge who was trying to be cool.

While Suge Knight may be considered a legitimate gangster thug who became wealthy in the rap game, being an Illuminati mafia gangster is something totally different. Illuminati mafia men don't get involved in fights outside clubs. They're far too sophisticated for that, but in many ways Suge is more dangerous than anyone in the Illuminati because he simply doesn't care about the consequences of his reckless actions and his repeated jail sentences have not seemed to deter him from criminal activity.

[172] Ibid
[173] *NY Daily News* "Suge Knight, Death Row Records CEO, arrested by swarm of LAPD officers" by Stephanie Gaskell (May 20th 2010)

Sean "Diddy" Colmes

PHOTO: Mug shot of Sean Colmes, CEO of Bad Boy Records.

Sean Colmes, Puff Daddy, Puffy, P. Diddy, Diddy, Little Diddy, whatever this poser's name is these days, released a music video in 1997, for a song titled "Victory" featuring Notorious B.I.G. and Busta Rhymes. The video takes place in the "New World Order," said to be in the year 3002 AD, in a society looking like something out of George Orwell's *Nineteen Eighty-Four* and depicts Diddy (or whatever his name is today) being chased by the police as part of a televised game show inspired by the Arnold Schwarzenegger film, *The Running Man* (1987).

This video was not really trying to warn people about the New World Order, but instead was a producer using a creative idea that Diddy was being persecuted by "the man." He is anything but persecuted by "the man," and instead during his fifteen minutes of fame, fourteen of which were done by exploiting Biggie's death, in my opinion, Diddy was a darling of the mainstream media machine who dished nothing but praise for Puffy, helping

him amass a fortune of almost $600 million dollars, making him the wealthiest man in hip hop.[174]

Let's not forget that Diddy was acquitted of bribery and weapons charges stemming from a shooting incident at a Times Square nightclub in 1999, after police reportedly found a stolen gun and a secret compartment built into his SUV after they pulled his vehicle over shortly after fleeing the scene of the shooting.[175] His protégé "Shyne," was sentenced to ten years in prison for reckless endangerment and assault after the rounds he popped off inside the club allegedly struck and injured three people.[176] Diddy can thank Johnny Cochrane for getting all the charges against him dropped; the famous lawyer who helped get O.J. Simpson quitted after he was charged with murdering his ex-wife.

[174] *Forbes* "Hip-Hop's Wealthiest Artists 2013: Sean 'Diddy' Combs ($580 million)

[175] *Billboard.com* "Driver Testifies At Puff Daddy Trial" (February 14th 2001)

[176] *MTV.com* "Shyne Sentenced To 10 Years In Prison" by Brian Hiatt (June 1, 2001)

Lauryn Hill

PHOTO: The Fugees album cover *The Score.*

Grammy Award winning female rapper and producer Lauryn Hill came on the music scene with her uplifting and socially conscious messages as a founding member of the now disbanded Fugees, along with Wyclef Jean and Pras Michel, whose 1996 album *The Score* is considered by many critics to be one of the best hip hop albums of the 1990s.[177] After the Fugees broke up, both she and Wyclef had successful solo careers, but Hill would later disappear from the public eye due to what she said were threats to her and her family. In 2013 she was sentenced to several months in jail for failing to pay her income taxes from 2005 to 2007, which was around a million dollars.[178] Some of her fans have claimed the conviction was in retaliation for her "conspiracy theories" about the music industry.

[177] *Rolling Stone* "500 Greatest Albums of All Time" (2012)
[178] *CBS News* "Lauryn Hill, Grammy Award-winning singer, sentenced to three months in prison for tax evasion" (May 6, 2013)

The previous year she had posted a message on her Tumblr account about how the music industry is "manipulated and controlled by a media protected military industrial complex." She also said the mainstream music industry engaged in "pop culture cannibalism."[179]

"For the past several years, I have remained what others would consider underground," she wrote. "I did this in order to build a community of people, like-minded in their desire for freedom and the right to pursue their goals and lives without being manipulated and controlled by a media protected military industrial complex with a completely different agenda."[180]

She went on to explain, "When I was working consistently without being affected by the interferences mentioned above, I filed and paid my taxes. This only stopped when it was necessary to withdraw from society, in order to guarantee the safety and well-being of myself and my family."

People like Lauryn Hill who challenge the establishment or openly oppose mainstream ideologies are often labeled "conspiracy theorists," and even mentally ill, and there is literally an official mental disorder listed in the *DSM-IV-TR Manual*, the official clinical manual on mental disorders, called "Oppositional Defiant Disorder," that claims people have a mental illness if they have "a recurrent pattern of negativistic, defiant, disobedient and hostile behavior toward authority figures that persists for at least 6 months."[181]

[179] *Rolling Stone* "Lauryn Hill Responds to Tax Evasion Charges" (June 11, 2012)
[180] Ibid
[181] *DSM-IV* "Diagnostic Criteria for Oppositional Defiant Disorder"

Many people believe Hill was targeted, harassed, and threatened because her music and her message is completely counter to the mainstream, materialist, self-destructive, soul sucking slime that is spread by the corporate controllers. Sometimes if you're not going to play their game, unimaginable dirty tricks get pulled.

Everything is Everything
What is meant to be, will be
After winter, must come spring
Change, it comes eventually
-*Everything is Everything*

Ice Cube

PHOTO: Cover for Ice Cube's single "Everythang's Corrupt."

In November 2012, just days before the presidential election, Ice Cube released a new video for his single "Everythang's Corrupt" (Get it? Every*thing* is corrupt? Every *thang*? Yeah. It's your typical ghetto speak that most rappers use, as I'm sure you're aware of.) Anyway, on the surface the video is pretty powerful and covers a lot of social issues from police brutality to political sex scandals, and even the strange mass deaths of birds and fish. When it was released it caused a wave of excitement and hope among many listeners who thought that Ice Cube was "awake" to the Illuminati, but the video was largely a publicity stunt and a one-sided attack against Republicans, because Ice Cube blindly supports President Obama.

"I don't see how anybody could believe what that man says," he told *Rolling Stone* magazine, talking about Republican presidential candidate Mitt Romney just before the election.[182] *Rolling Stone* wrote, "The West Coast hip-hop luminary's new single, 'Everythang's Corrupt,' is a no-holds-barred, politically charged record that plumbs the seedy, greedy underbelly that stinks up so much of American society."[183]

In the interview, Ice Cube described himself as a "Political Head" who followed the 2012 presidential race very closely and said Obama hadn't been able to accomplish all of his goals in his first term because of a "do-nothing Congress," and said the song was largely inspired by the Occupy Wall Street Movement, the largely liberal, Obama supporting, socialist, big government demonstrators who made headlines in 2011 for camping out, or "occupying" public property while demanding a long list of absurd things from forgiving student loan debt and offering "free" tax payer funded college tuition, to insanely high minimum wages, and an endless list of government handouts.

Ice Cube made a career out of promoting violence as a founding member of the 1990s rap group NWA (Nigga's With Attitude) with their flagship single, "Fuck the Police," only to transition later into family comedies like *Are We There Yet?* and *Barbershop*. The fact that supposedly family friendly studios would cast Ice Cube as a star in their films speaks volumes about the lack of standards these studios hold.

[182] *Rolling Stone* "Ice Cube on Mitt Romney: 'It's Astonishing That People Are Buying That'" by Jon Blistein (November 1, 2012)
[183] Ibid

In a perfect world Ice Cube, who has spoken favorably of the black supremacist Nation of Islam and considers himself a Muslim,[184] would be blacklisted from mainstream media and stuck working at a Seven Eleven in the ghetto, but in an Illuminati controlled entertainment industry, he has made many millions of dollars and is loved by the zombie masses.

Charly Boy

Illuminati musician allegations aren't just limited to American artists—believe it or not—a popular rap artist in Nigeria is accused of being in the Illuminati, and being gay as well. Of course popular artists in other countries such as Europe, China, Japan and more, are probably accused of using Illuminati symbolism or claiming some kind of allegiance with them, but at the time of this writing, it's mostly American stars who are swept up in the allegations.

"Last week, news spread like a hurricane about Charles Oputa popularly known as Charly Boy being a gay and the head of Illuminati in Nigeria," read the *National Mirror*, a daily newspaper in Nigeria.[185] A local pastor named Roland Macaulay made the allegations and then Charly Boy threatened to sue the paper for publishing them.[186] Charly Boy, who is 60-years-old, responded, saying, "Yesterday, I was an Illuminati

[184] *The Guardian* "Chillin' with Cube" (February 24, 2000)
[185] *NigeriaFilms.com* "Charly Boy Reacts To Gay Allegation Story" by Osaremen Ehi James (May 28, 2012)
[186] Ibid

member. Today, a gay, tomorrow, sleeping with a coffin and the list is endless. When will they stop these lies?"[187]

Some believe that Charly Boy and the writer of the story collaborated together as a publicity stunt for the artist, something that could very well be possible due to the attention Illuminati allegations have been receiving in the United States. He wasn't just accused of being "in" the Illuminati, he was actually said to be the "head" of the organization in Nigeria! A claim that is clearly absurd to anyone who knows anything about the subject. Nevertheless it is interesting to hear that the Illuminati allegations aren't just isolated to American musicians, but they have popped up in South Africa as well.

[187] Ibid

Tyler the Creator

PHOTO: Cover for Tyler The Creator's *Goblin* album.

A fairly popular "shock rapper," whose lyrics are designed to be as vile as possible and include themes of rape and murder fantasies, found favor with Sony Music Entertainment and other major corporations who use their influence and infrastructure to spread his bile to the brains of the buffoons who are dumb enough to willingly listen to it. This creature's name is Tyler the Creator of the group Odd Future, who's friends with Justin Bieber of all people, despite calling himself a Christian.

This baboon is basically a black Eminem, and after his debut album *Goblin* came out in 2011, many critics gave it positive reviews. Jon Dolan from *Rolling Stone* gave the album 3 and a half, out of 5 stars, and enjoyed the "lush, left-field R&B-tinged tracks" and its "early-Eminem evil" lyrics. [188] *Allmusic.com's* David

[188] *Rolling Stone* "Tyler the Creator" by Jon Dolan (May 10, 2011)

Jeffries also gave it 3 and a half out of 5 stars, saying "Tyler's production is as attractive as ever, contrasting his disgusting rhymes and gruff voice with subdued, sometimes serene beats that echo and creep."[189]

Slant Magazine awarded the album 4 and a half out of 5 stars when critic Huw Jones wrote in delight that, "Goblin could well be one of the decade's most significant releases...a masterpiece for those capable of stomaching it."[190]

Fortunately a few critics still had some common sense and slammed Tyler, because, "Eminem already did this 15 years ago," as Joshua Erret of *Now Magazine* said, [191]and Randall Roberts from *The Los Angeles Times* wrote that after listening to it for a bit, "you just want Tyler the Creator to shut the hell up."[192] MTV News once asked Tyler about rumors he and his group Odd Future were connected to the Illuminati, to which he responded, "Oh, that's cool! People think I'm in the Illuminati? That's tight—hell yeah! That's tight—you've got to be rich as fuck to be from there, or have power! That's people implying that I'm rich as fuck and we have power—that's tight!"[193]

[189] *AllMusic.com* "Tyler the Creator Review" by David Jeffries
[190] *Slant Magazine* "Tyler the Creator Review" by Huw Jones (May 6, 2011)
[191] *Now Magazine* Volume 30 Number 37 "Tyler, The Creator Goblin" by Joshua Errett (May 12-19, 2011)
[192] *Los Angeles Times* "Album review: Tyler, the Creator's 'Goblin'" (May 10, 2011)
[193] *MTV.ca* "Odd Future React to MTV News Suggesting They are Part of the Illuminati" by David Robert (April 18, 2012)

Big Boi

PHOTO: Big Boi tells New York's Hot 97 he voted for Libertarian candidate Gary Johnson, instead of Barack Obama in 2012.

While Barack Obama received 93% of the African American vote in the 2012 election[194] (down from 95% in 2008 when he was first elected president)[195] and the entire rap and hip hop industry couldn't have been more proud to get "one of their own" into office, there was at least one famous rapper who did not support Obama—and that was rapper Big Boi, one half of the Grammy Award winning duo Outkast.

Big Boi and his friend Andree 3000 formed the group while still in high school and the two went on to later win six Grammies and sell over 25 million albums, making them one of the most successful hip hop duos of all time. Just after the 2012 election, Big Boi was giving an interview to New York Hot's 97 when he revealed that the day after the election a white woman at the airport

[194] *CS Moniter* "Election results 2012: Who won it for Obama?" by Peter Grier (November 7, 2012)
[195] *CNN* "Is Obama taking black vote for granted?" by Shannon Travis (July 13, 2012)

congratulated him on "his win last night," referring to Barack Obama's victory over Mitt Romney, thus winning a second term; to which Big Boi responded, "Bitch, I voted for Gary Johnson" [196] (the candidate for the Libertarian Party). This came as a shock to many, and a pleasant surprise to others, who were glad Big Boi wasn't supporting Obama like so many other black musicians were, simply because he was black too.

By revealing he didn't support Obama, and instead voted for a third party candidate who became the favorite of many Ron Paul supporters after he dropped out of the race, it showed that Big Boi had a deeper knowledge of the mechanisms at work in presidential politics, leading some to believe that had discovered the invisible empire that controls both major political parties, and wanted nothing to do with either of them.

While Big Boi, at the time of this writing, hasn't spoken publicly about the Illuminati, he has followed me on Twitter for quite some time, occasionally retweeting some my tweets, which is an indication that he has some interest in the Illuminati which led him to me. Being a black rapper and publicly stating he didn't support Obama took some big balls, and Big Boi should be commended for daring to make his views known publicly, which could have been potentially damaging to his career.

[196] *Hot 97* "Big Boi stops by the Cipha Sounds And Peter Rosenberg Morning Show with K. Foxx" (November 14, 2012)

Killer Mike

PHOTO: Killer Mike interviewed on Power 105.1's *The Breakfast Club* where he talked about gun rights.

Atlanta based rapper Killer Mike did a lengthy interview with *The Breakfast Club* on Power 105.1 out of New York where he talked about the mainstream music industry, the Constitution, the Police State, the Patriot Act, and other Liberty issues revealing he was more informed than the average rapper about current events. When asked why he hadn't yet "made it" in the mainstream, he answered, "Eventually somebody's going to be courageous enough to play it on the radio...eventually, or not, someone on this side of the fence is going to have the confidence [to play his music] cuz it's not like my music doesn't do what it's supposed to do...whenever they want me, I'm here, but I can't pander myself and I can't allow myself to be used and abused."[197]

When the topic of guns came up during the interview, Mike stated, "I think every American can and

[197] *Power 105.1* "The Breakfast Club" (March 21, 2013)

should own a firearm," to which a bewildered host gasped, "why?"

"Because it's our right and because I've been around the world and I've seen what countries who don't have that right are like," he answered, and then highlighted that we live in Constitutional Republic, something most people don't understand.

There is an important difference between a republic and a democracy, and the United States of America was originally supposed to be a republic, which is a representative form of government where the government's power is limited by a charter or Constitution that sets boundaries which must not be violated no matter what, thus permanently protecting people's basic freedoms, protections that a majority vote cannot overrule. In a democracy, the majority rules, and there are no limitations to the powers or actions a government can take if the majority of people want them (or are tricked or coerced into wanting them). A popular analogy is that a democracy is two wolves and a sheep voting on what's for dinner. In a republic, even if the two wolves voted to eat the sheep, their two-thirds majority vote still wouldn't allow them to kill the sheep because the sheep's rights are protected by the constitution which trumps any majority vote.

As the conversation about gun violence was pressed by the host during Killer Mike's interview, he said, "If you're familiar with MK-ULTRA, if you're familiar with how governments set up to take the rights of people, you've seen all this shit happen before. I am an American. I refuse to give up the rights that were given to me in the Bill of Rights and the Constitution."

He went on, "Why is the Patriot Act in effect? Because at some point in the near or far future, this

country is going to become a country in which you don't have the rights you have now. And the only thing that has ever stood in opposition to that in America is that the citizenry is armed. If you do not have an armed citizenry, you have a controlled citizenry." The top comment on the YouTube video read "Killer Mike! The only top tier rapper who defends the Constitution!"

He also talked about Big Pharma and our drugged and sedated population, saying sarcastically, "Don't work out, don't eat healthier, don't take yoga, just take a pill." At the time I'm writing this, his Twitter background is an American flag with an Illuminati All-Seeing Eye in the upper left hand corner surrounded by the stars, signifying the Illuminati owns America.

Mike owns a barbershop in Atlanta, Georgia, and plans to pursue his dream of opening over one hundred shops in the United States, primarily in black communities. [198] He entered the music scene by appearing on Outkast's Grammy-winning single "This Whole World" in 2001. It's interesting to note that Killer Mike became friends with Big Boi of Outkast in college, who, as I've previous noted, is one of the few mainstream rappers who didn't mindlessly support Barack Obama like virtually every other black entertainer in the industry did.

[198] *Barber-Schools.org* "Killer Mike's Barber Shop in Atlanta, GA" (July 2, 2012)

Talib Kwali

PHOTO: Talib Kwali sits down with DJ Vlad's VLADTV to discuss the Illuminati.

Brooklyn based rapper Talib Kwali, who got national recognition for his 2002 socially conscious song "Get By," was once interviewed by DJ Vlad and asked about the Illuminati rapper rumors, where he then called them a distraction from more important issues.

"We have the International Monetary Fund, the World Bank. We have rich families that are conspiring and getting together to have one currency, to have one world order to make shit easier for them. These things are dangerous and catastrophic for millions of people—some of these decisions that these rich people make. But when you start adding a boogieman 'Oooh mysterious secret society' aspect to it, you really distract from the real issues, and you're not giving enough props and credit to show how dangerous and evil some of this shit really is."[199]

[199] *VladTV* "Talib Kweli Calls Jay-Z Illuminati Rumors a Distraction" (May 21st 2013)

During the interview he explained how he read Bill Coopers popular book *Behold a Pale Horse* in the 1990s but later realized how inaccurate Cooper was and blamed much of the "anti-Illuminati sentiment" on what he called "right wing, conservative Christian think tanks, John Birch Society types who felt the need to demonize Freemasons and demonize these groups at the beginning of America. So, it's all religious stuff," Talib said. "The Illuminati was a real organization," he went on, "and could quite possibly be a real organization now, but the amount of power people allow it to have on their lives is based on them."[200]

While Talib Kwali may be a skilled and socially conscious rapper, his interview with DJ Vlad's VLADTV revealed how little he knows about the John Birch Society, which was instrumental in exposing the Illuminati "insiders," as they called them, starting in the 1960s by publishing books like Gary Allen's *None Dare Call it Conspiracy*. Talib does, however, have a point about many of the Illuminati rapper rumors being clearly crazy and actually often do distract from tangible, real organizations and issues that society is facing.

> The TV got us reaching for stars
> Not the ones between Venus and Mars,
> the ones that be reading for parts
> *-Get By*

[200] Ibid

Jadakiss

In 2004, Jadakiss released his second album titled *Kiss of Death* which included a track titled "Why?" containing a line that set off a media firestorm and caused his song to either be pulled from the radio in many markets, or censored if it actually was played.

The line that resulted in so much controversy was, "Why did Bush knock down the towers?" referring to the World Trade Center attack on 9/11. As I'm sure you're familiar with, many people believe the September 11th attacks in 2001 were an "inside job" and a false flag conspiracy orchestrated by elements of the US government or the Illuminati. A variety of books and films were made about this very issue, and a number of people have made headlines for either raising questions as to whether the attacks were an inside job or if they were allowed to happen on purpose as a pretext for the endless War on Terror. After hearing about Jadakiss's song, Fox News' Bill O'Reilly suggested that President Bush sue him for slander.

While it was, in my opinion, admirable for Jadakiss to use his art to raise the question, this is not to say that Jadakiss is a quality artist or a positive role model by any means. Quite the opposite, he is just another one of countless wannabe gangster rappers who speaks with a ghetto accent without a proper grasp of the English language, seeming to wear his ignorance as a badge of honor.

Lupe Fiasco

PHOTO: Lupe Fiasco is interviewed by Luke Rudkowski of
We Are Change about a possible 9/11 cover-up.

Of course practically every black person in the
entertainment industry (if not the country) saw Barack
Obama as a virtual messiah for the African American
people when he appeared on the scene and was placed in
the Oval Office, but Lupe Fiasco didn't believe the hype.
While giving an interview on CBS he called Obama "the
biggest terrorist in the United States,"[201] because of his
expansion of George W. Bush's War on Terror, most
notably becoming the "King of the Drones," those radio
controlled murder machines that have killed countless
innocent civilians in the Middle East—atrocities that are
censored in the American media.[202]

Lupe's comments caused quite a bit of controversy
and when he was later asked by *Billboard* to clarify his

[201] *USA Today* "Rapper Lupe Fiasco calls Obama 'biggest terrorist'"
by Arienne Thompson (June 8, 2011)
[202] *London Telegraph* "168 children killed in drone strikes in Pakistan
since start of campaign" by Rob Crilly (August 11, 2011)

statement, he responded, "I've got nothing to clarify. It's Obama and the U.S. government, every president that came before him and every president that comes after him."[203] Such statements rarely compute with the public, who are too busy watching celebrity news to know (or care) about the grave injustices that both Republican and Democrat presidents commit, each side believing that only their opposing political party violates the Constitution.

Several years earlier at the end of his set on *The Late Show with David Letterman* when Lupe performed his single "Superstar," you can clearly hear him say, "No New World Order, ya hear me."[204] Somehow, despite all this, Lupe was still invited to a 2012 inauguration party at the Hamilton in Washington DC, where he took to the stage and performed his song "Words They Never Said," over and over again, rapping, "[Rush] Limbaugh is a racist, Glenn Beck is a racist, Gaza Strip was getting bombed, Obama didn't say shit. That's why I ain't vote for him, next one either."

The audience was stunned and eventually he was pulled off stage and the event organizers made a statement saying, "Lupe Fiasco performed at this private event, and as you may have read, he left the stage earlier than we had planned," because of what they called his "bizarrely repetitive, jarring performance that left the crowd vocally dissatisfied."[205]

[203] *Billboard* "Lupe Fiasco on Calling Obama a Terrorist: 'I've Got Nothing to Clarify'" (June 9th 2011)

[204] *CBS* "The Late Show with David Letterman" (January 2nd 2008)

[205] *Hollywood Reporter* "Lupe Fiasco Sings Anti-Obama Song, Rushed Off Stage at Inaugural Event" by Jordan Zakarin (1/21/2013)

General Gemineye

PHOTO: A scene from "Ambushed" featuring General Gemineye, produced by DJ Ball, a sharp critique of the War on Terror.

A Vancouver, Canada rap duo named Conspirituality released a song titled "AmBUSHED" in 2009 on their debut album which contains lyrics about the 9/11 attacks on the World Trade Center, Bohemian Grove, the Illuminati, and the Bush Administration's war crimes. A powerful and controversial accompanying video was produced by DJ Ball that depicts men in orange Guantanamo Bay-style prison jumpsuits chasing down President Bush, Dick Cheney, Condoleezza Rice and other architects of the Iraq War as they run for their lives to avoid being brought to justice.

The Guantanamo Bay detention camp is a prison and interrogation facility located at the American-run Guantanamo Bay Naval Base in Cuba that was built in 2002 by the Bush Administration as a place to keep suspected terrorists without giving them a trial and essentially detaining them indefinitely without even charging them with a crime. The facility has been called a "gulag of our times" by Amnesty International and

condemned by civil rights groups.[206] An estimated 800 people are being held there,[207] and for years the US government had not released the identities of all prisoners.[208]

Many of the inmates have been tortured by American military personnel, similar to the Abu Ghraib torture and prisoner abuse scandal in 2004 which was uncovered after photos were published in the press that were taken by guards who worked at the facility showing a variety of inhumane treatment and abuse.[209] The photos were taken as trophies for the guards and showed them enjoying abusing the prisoners in bizarre and disgusting ways. These were the issues addressed in the music video for "AmBUSHED" and why it depicted prisoners revolting against President Bush, Vice President Dick Cheney, and others.

Conspirituality's front man, General Gemineye, later released a music video for his solo track "Bohemian Rap City" (a play-off of Queen's "Bohemian Rhapsody"), a song about the Bohemian Grove and the Illuminati activities within. The music video even features a scene where General Gemineye is shown reading my previous book, *The Illuminati: Facts & Fiction*.

> The cremation of care to the creation of fear
> This location is where they vacation each year
> My frustration I swear is for the whole nation to hear
> My donation to your ear is world domination is near
> *-Bohemian Rap City*

[206] *CNN.com* "Rumsfeld rejects Amnesty's 'gulag' label" (June 1, 2005)
[207] *BBC* "Q&A: Guantanamo detentions" (April 30th 2013)
[208] *FoxNews.com* "US names Guantanamo Bay prisoners designated for indefinite detention" (June 17, 2013)
[209] *The New Yorker* "Torture at Abu Ghraib: American soldiers brutalized Iraqis" by Seymour M. Hersh (May 10, 2004)

Immortal Technique

One of the more popular underground artists is Immortal Technique, a rapper whose every word is a blistering attack on the 9/11 cover-up and the War on Terror in songs like "Bin Laden" and "Cause of Death" which inundate the listener with hard facts and evidence delivered with a unique poetic power. "You think Illuminati's just a fucking conspiracy theory?" he blasts.

Most of his songs focus on government corruption, poverty, racism, and other social issues, and while I do appreciate some of his tracks, others I've heard contain violent and angry messages I simply don't care for. Immortal Technique was also very vocal in his support for the Occupy Wall Street movement which was virtually a foot soldier army of big government, liberal, Obama supporters demanding free stuff—from housing to healthcare, to college education and "living wages," all at the expense of our nation's tax payers.[210]

All they talk about is terrorism on television
They tell you to listen,
but they don't really tell you they mission
They funded Al-Qaeda,
and now they blame the Muslim religion
Even though Bin Laden, was a CIA tactician
They gave him billions of dollars,
and they funded his purpose
Fahrenheit 9/11, that's just scratchin' the surface
-Bin Laden

[210] *Occupy Unmasked* (2012) directed by Stephen K. Bannon and produced by David Bossie. Distributed by Magnolia Pictures

Paris

PHOTO: Cover for *What Would You Do* by Paris.

A rapper named Paris on the Guerilla Funk record label has produced numerous songs about the New World Order and the Illuminati, with one of his most popular tracks titled "What Would You Do?" In the song, Paris exposes the Illuminati's agenda with the power and precision of any chart-topping single, but because the content isn't "mainstream friendly," it didn't get any airplay on the corporate controlled radio stations.

Another Bush season mean another war for profit
All in secret so the public never think to stop it
The Illuminati triple six all connected
Stolen votes they control the race and take elections
It's the Skull and Bones Freemason kill committee
See the Dragon getting' shittier in every city
-What Would You Do?

119

N.O.R.E.

In an interview with *Urban Daily*, N.O.R.E. (formerly known as Noreaga) was asked about the Illuminati hip hop rumors, and answered, "The way they're describing it with the devil worship, that's all fabricated and over exaggerated...But there is a certain level that you can't get to unless you're aware of certain things. There is a door you have to walk through and it's on you to walk through that door. And once you walk through that door, there is no coming back."[211]

As far as N.O.R.E.'s belief that the "devil worship" is "fabricated," he is just showing his limited knowledge of the issue, and has most likely just seen some of the countless conspiracy YouTube videos that accuse just about every celebrity of being a Satanist or an Illuminati puppet. Anyone with a fair amount of knowledge about the Illuminati knows one of the core secrets of many occult fraternities is that high level members view Lucifer or Satan as the true God, or the source of their light and power.

Helena Blavatsky, author of *The Secret Doctrine*, a book that largely inspired Adolf Hitler's Nazi philosophy, wrote, "Satan will now be shown, in the teaching of the Secret Doctrine, allegorized as Good, and Sacrifice, a God of Wisdom."[212] Later in the book, she goes into detail, clearly explaining what the "Secret Doctrine" is, saying, "Lucifer is divine and terrestrial light, the 'Holy Ghost' and 'Satan,' at one and the same

[211] *The Urban Daily* "N.O.R.E On The Illuminati: 'There Is A Door You Have To Walk Through'" by Jerry L. Barrow (March 20, 2013)
[212] Blavatsky, H.P. - *The Secret Doctrine* v. II p. 237

time, visible Space being truly filled with differentiated Breath invisibly…The Fall was the result of man's knowledge, for his 'eyes were opened.' Indeed, he was taught Wisdom and the hidden knowledge by the 'Fallen Angel'…And now it stands proven that Satan, or the Red Fiery Dragon, the 'lord of Phosphorus' (brimstone was a theological improvement), and Lucifer, or 'Light-Bearer,' is in us: it is our Mind—our tempter and Redeemer, our intelligent liberator and Savior from pure animalism…Without this quickening spirit, or human Mind or soul, there would be no difference between man and beast."[213]

33rd degree Freemason Manly P. Hall echoes these views in *The Secret Teachings of All Ages*, writing, "The serpent is true to the principle of wisdom, for it tempts man to the knowledge of himself. Therefore the knowledge of self resulted from man's disobedience to the Demiurgus, Jehovah."[214]

New Age Illuminati guru Alice Bailey admitted point blank in her famous book *The Externalization of the Hierarchy* that when the "Hierarchy's" plans are complete, the ruler of planet earth will be Lucifer.[215]

[213] Blavatsky, H.P. - *The Secret Doctrine* v. II p. 513
[214] Hall, Manly P. - *The Secret Teachings of All Ages* p. 272
[215] Bailey, Alice - *Externalization of The Hierarchy p. 107*

Die Antwoord

PHOTO: Die Antwoord's video "Fatty Boom Boom" depicts several famous pop stars as being part of an "Evil Thing."

A bizarre South African rap-rave group that got some attention in the United States for a brief period of time is Die Antwoord (Afrikaans for 'The Answer'), and while their brand of music is quite disturbing and unappealing, it is noteworthy that they produced a music video depicting Lady Gaga getting mauled by a lion! The video for "Fatty Boom Boom" also shows Gaga, along with Kanye West, Pitbull, Nicki Minaj and Akon as heads of a monster with the words "Evil Thing" written above it.

What happened to all the cool rappers
from back in the day?
Now all these rappers sound exactly the same
It's like one big inbred fuck-fest
-Fatty Boom Boom

Hopsin

PHOTO: Hopsin in his video "Ill Mind of Hopsin 5" where he warns kids about going down the wrong path.

Popular rappers who are against drug and alcohol abuse is practically an oxymoron, but sometimes there are rare exceptions to the rule. One of those is Hopsin, who realizes the influence he has over his young fans and includes empowering messages in his music denouncing irresponsible sexual behaviors, drug use, and the culture of prideful ignorance that has taken over hip hop.

He wasn't always dedicated to spreading a positive message, but says he realized once he "made it" as a rap star and understood how much influence he had over his young fans, he had an epiphany and decided to wield his power responsibility. "I saw all these kids and they were praising me, I've seen it on DVD's with Michael Jackson and Eminem, but I never actually been the guy when kids come up to me and are starstruck, and I was like wow, what the heck is going on right now?"[216]

[216] *Hip Hop Wired* "Hopsin Speaks On Idol Worship and The Illuminati" by Joseph Poakwa (October 2, 2012)

Hopsin says he hopes to provide a positive influence so his fans can find the ladder of success, and you can't do that, he says, if you're heavily into drugs or drop out of school. In July 2011 he released "Ill Mind of Hopsin 4," which includes a verse dissing Tyler the Creator of Odd Future, the scumbag known for his violent and perverted "shock rap" lyrics. The video for "Ill Mind of Hopsin 5" shows Hopsin basically lecturing a group of teenagers about blowing off their education, smoking too much weed, and sleeping around. The entire video takes place in what looks to be a typical teenager's bedroom that's covered with posters of celebrities and black lights.

Hopsin credits God with awakening him to reality and has become very spiritual, saying, "It may seem corny because we've been brainwashed to think that it's corny. When you think about somebody giving their life to God, you're like 'aw man, he's gone now, he ain't the same guy.' No, if God really does exist, if he is the creator of this whole Universe, and this world, what's wrong with that? What's wrong with glorifying the God who created the Earth?"[217]

Do you even have any goals?
Aside from bagging these hoes
And packing a bowl
Well let me guess, NO!
-*Ill Mind of Hopsin 5*

[217] Ibid

MC Hammer

PHOTO: MC Hammer baptizes "Jay-Z" in his video "Better Run, Run" after the 1980s superstar calls out the superstar for dealing with the Devil.

If you grew up in the late 1980s or early 1990s, you are undoubtedly familiar with MC Hammer's hit "U Can't Touch This," and his trademark parachute pants. Many people consider MC Hammer a quintessential one-hit wonder, and after shooting to superstardom, his time in the limelight soon faded like so many others before him.

After his rap career came to a crawl and all but ended, he became an ordained minister and launched a television ministry show on the Trinity Broadcasting Network titled *MC Hammer and Friends* to speak about his Christian faith. "MC," he said, now stood for Man of Christ.

Years later, having caught wind of the Illuminati epidemic in rap and hip-hop, Hammer released a song and

music video titled "Better Run Run," that called out Jay-Z as a Devil worshiper and the entire track was essentially a Jay-Z diss. The music video featured a figure representing Jay-Z running from the Devil and concluded with MC Hammer baptizing him to cleanse him of his demons.

> I could see it in his eyes, the boy sold his soul
> Devil said I'ma give you the world
> I'll take it, plus give me a girl
> Mr Devil can you give me a sign
> He said 'Throw the Roc up, that's one of mine'
> -*Better Run, Run*

KRS-One

One of the old school rappers who represents the art form for what it was before it became hijacked and perverted by Illuminati media companies is KRS-One, a name that stands for Knowledge Reigns Supreme Over Nearly Everyone—a dude who's been in the rap game since 1984.

After over twenty years representing what hip hop was meant to be, KRS-One was given the Lifetime Achievement Award in 2008 by BET, acknowledging his quality contributions to music, as well as his personal efforts to improve people's lives though his Stop the Violence Movement, which he started in 1998.

KRS-One has been very vocal on issues such as poverty, violence, education, and war, and was featured on the remix of Immortal Technique's song "Bin Laden," which blames the 9/11 World Trade Center attacks on the

Bush Administration. KRS-One was one of the featured speakers at a benefit in New York City for the first responders of the 9/11 attacks, many of whom are sick or have died from breathing the toxic air during rescue efforts—air that Christie Whitman, the head of the Environmental Protection Agency (EPA) at the time, lied about when saying it was safe to breath. [218] The fundraiser was organized by Luke Rudkowski and his organization We Are Change.[219]

The rapper also appeared in *The Obama Deception*, a popular 2009 film produced by Alex Jones from Infowars.com, where he said, "Barack is like the manager of Burger King. All presidents are, including Bush. It's like this: when your fries are cold, your burger's not done right, you go back to Burger King/'America' or your 'Government,' and you say, 'My burger's cold! I want new fries!' First, you go to the cashier. That's the 'courts.' You argue to the courts. The courts if you can't get justice with the cashier, you say 'Let me see the manager! I wanna go to the Supreme Court! I wanna see the President!' The manager comes out. 'Hi. What can I do for you?' Now the manager can override the decisions of the cashier, but you never get to see the franchise owner of Burger King. If you really have a problem with your burger, you need to go see the franchise owner! We need to go to the top... or to the bottom. We need to go to where the real architecture of government is, and it's not in a president! It's in a global scheme!"[220]

[218] *CBS News* "W. House Molded EPA's 9/11 Reports" (September 10, 2009)
[219] WeAreChange.org
[220] *The Obama Deception* (2009) produced by Alex Jones

So add KRS-One to the very short list of black entertainers who saw through the Obama hype, and who wasn't jumping for joy just because a man with the same skin color moved into the White House. The 1990s rock band Sublime paid tribute to KRS-One in a song by the same name, where singer Bradly Nowell praised the rapper for his enlightening and educational music.

Because he's droppin', droppin', droppin' science,
droppin' history
With a whole leap of style and intelligency
Yes, I know
I know because of KRS-ONE
Yeah, and I know
I know because of KRS-ONE
-*KRS One, by Sublime*

Bizzle

A Christian rapper named Bizzle has produced several quality "diss" songs aimed at Jay-Z and his apparent adoration for the Devil, and surprisingly, Bizzle actually has some skills and sounds like a pro. The rapper, whose motto is "God Over Money," has produced several quality tracks and professional music videos calling out other rappers for their use of Illuminati and Satanic imagery in their acts and their overall destructive messages.

In an interview with *Hip Hop Wired*, Bizzle was asked what his goal was regarding his music, to which he answered, "I just want to reach people for the Lord. There are a lot of people in the hood right now who love the Lord with all their heart, but when you grow up in the

hood your perception of love is different. So I think it's just showing people who grew up like me God's way of loving us so that we can see His will for our lives and become better as a people and know that we can get better because that is God's intention for us all."[221]

He continued, "Also I think that my music is drawing a line, because there are people out there who listen to Odd Future, who are Christian, and hear him [Tyler the Creator] totally dissing God but because they like his music they dismiss it. So in a way, it's forcing you to make a decision, because we are not taking these negative things personal. I know we have a lot going on in our lives, but we have to focus on the real objective which is Jesus Christ."[222]

While Christian rap may seem to be an oxymoron at first with most Christian rappers not packing the punch listeners have come to expect from rap music, Bizzle is certainly in a league of his own, and shows that a Christian rapper can produce quality music that doesn't have the typical "cheesiness" associated with Christian rap.

> Nigga just claim what you is
> I'm hearing you a Mason
> So explain the pyramids that
> You sit on the stage
>
> I know about you and the law of Thelema
> Know about Crowley and the cult you believe in
> Is it just in my mind or is it you're blind to the
> Roc-a-wear designs, symbolism and signs
> *-Got Some Explaining To Do*

[221] *Hip Hop Wired* "Christian Rapper Bizzle Sends Justified Shots To Jay-Z's So Called 'Throne'...Find Out Why" by tffhthewriter (August 26, 2011)
[222] Ibid

Saigon

One socially conscious "anti-Illuminati" rapper had his debut album shelved by Atlantic Records because the corporate giant allegedly didn't like the message that the rapper was sending out and tried to make him change his image. Saigon explained, "They signed me knowing the kind of music I was making, but then they try and change the direction."[223]

When he wouldn't go along with their plan for him and change his tune, that's when he says the problems began, ultimately delaying his debut album for years. "They held me for six years, and it got to the point, I begged them to let me go and make a living. They said they would rather hold me and shelve me until I was nothing. They are paper gangsters and contract thugs."[224]

While his album was being held up he earned money from doing shows and even appeared as himself in the popular TV show *Entourage*. "Atlantic didn't care if I lived or died, they just didn't want to see me succeed. They invested in me and I didn't do what they wanted, so they shelved me," Saigon claimed.[225]

He posted a message on his MySpace page saying Atlantic Records didn't want to release his album because he was a "real artist," not a "jingle writer" and claimed that they only cared about making money and not the

[223] *BallerStatus.com* "Q&A: Saigon Talks Industry Woes, The Illuminati & Music Stars' Death Conspiracies" by Zac Shull (November 21, 2012)
[224] Ibid
[225] Ibid

content of the music.[226] One of the main producers connected to his Atlantic Record deal was Justin Smith (known in the industry as Just Blaze), who is best known for producing songs for Jay-Z and other elite artists.

Finally after years of legal battles, Saigon's lawyers were able to get him released from his contract and retain the rights to his album, *The Greatest Story Never Told,* which was finally released in 2011 through Suburban Noize Records, an independent label run by Kottonmouth Kings vocalist Brad Xavier.

Saigon became a rapper in prison after he was locked up for shooting someone at a bar in the 1990s, and credits his incarceration for helping him see the light. He says a fellow prisoner named Hakim helped him see the error of his ways through battle rapping. He was released from prison in the year 2000 and was determined to achieve his goal of getting a record contract. Atlantic Records probably saw him as an appealing act at first because of his "rep" and prison stint, knowing this would make him more marketable to the mainstream music consumers, but they misjudged the rapper, who instead of embracing and bragging about his criminal past, learned from it and changed his ways.

Talking about the meaning of his second album, *The Greatest Story Never Told: Bread and Circuses*, he said, "It's a Roman ideology about public control and how to divert the public from the real issues. Bread and circuses is food and entertainment, so you keep their belly filled and keep them entertained, and you can do whatever

[226] *HipHopDX* "Saigon Is Released From Atlantic Records" by Andreas Hale (May 21, 2008)

you want really. I feel like that's how the world works right now."[227]

When asked by hip hop news website *Baller Status* about the Illuminati, he explained, "Everybody knows the Illuminati is real and secret societies exist. The New World Order is real...If someone has a revolutionary mindset, they aren't going to let that person accumulate that much money. They want people who are just going to floss and go on vacation. Let someone like me get that much money and you would see a whole different situation."[228]

In the interview, Saigon made it clear that he knows what it takes to become a successful mainstream rapper these days, but won't compromise his values to become a part of that machine. "I have to say the truth, even though I know what sells and what doesn't. If I was pushing death and destruction, I would be a lot more popular than I am now. All the popular rappers push death, destruction, sex and pimping. They get corporate sponsorships and now hip-hop is one big commercial."[229]

How right he is. Mainstream hip hop basically is one giant commercial—a commercial for Satanism and the biggest satanic stars are endorsed by soda companies, major brands, and an entire web of interconnected corporate partnerships.

[227] *BallerStatus.com* "Q&A: Saigon Talks Industry Woes, The Illuminati & Music Stars' Death Conspiracies" by Zac Shull (November 21, 2012)
[228] Ibid
[229] Ibid

BET: Black Entertainment Television

PHOTO: The Logo for BET: Black Entertainment Television.

Black Entertainment Television (BET), as you may know, is a major cable television channel owned by media giant Viacom that is the most prominent "African American" cable channel in the world, getting pumped into more than 90 million homes.[230] The channel was created in 1980 by Robert L. Johnson, and serves largely to perpetuate negative African American stereotypes and promote mainstream rap music. The network has been repeatedly criticized by non-brainwashed blacks, including Reverend Delman L. Coates, Public Enemy's Chuck D and filmmaker Spike Lee, who see the channel for the trash can that it is.

Robert L. Johnson, the network's creator, became the first African American billionaire when he sold BET to Viacom in 2001.[231] That's right. He became the first black billionaire in America, years before Oprah Winfrey.

[230] *TV by Numbers* "List of How Many Homes Each Cable Networks Is In - Cable Network Coverage Estimates As Of August 2013" by Robert Seidman (August 23rd, 2013)
[231] *USA Today* "From BET to hotels to banking, Johnson keeps moving forward" (4/12/2006)

In a 2010 interview, co-founder Sheila Johnson, who made over a billion dollars with her husband (before their divorce) when they sold the network to Viacom, said she is now "ashamed" of what BET has become. "I don't watch it. I suggest to my kids that they don't watch it," she said. "When we started BET, it was going to be the Ebony magazine on television. We had public affairs programming. We had news...I had a show called *Teen Summit*—we had a large variety of programming, but the problem is that then the video revolution started up... And then something started happening, and I didn't like it at all. And I remember during those days we would sit up and watch these videos and decide which ones were going on and which ones were not. We got a lot of backlash from recording artists...and we had to start showing them."[232]

Even though it's geared for black people, the channel didn't even cover the funeral of Martin Luther King Jr.'s wife, Coretta Scott King, in 2006, and while CNN, Fox News Channel, MSNBC, the Black Family Channel, and TV One [another channel geared for black people] all aired live coverage of Coretta Scott King's funeral, BET aired its regularly scheduled programming of mindless music videos.[233]

In an episode of the *Boondocks*, a comedy cartoon for adults on the Cartoon Network, Martin Luther King Jr. was once depicted as if he was still alive today and gave a speech lambasting "niggas," and called Black Entertainment Television the worst thing he had ever seen in his life. "I know some of you don't want to hear me

[232] *Daily Beast* "Sheila Johnson Slams BET" (April 29, 2010)
[233] *Tampa Bay Times* "Coretta Scott King Coverage: What Does it Take to Get BET's Attention?" by Eric Deggans (February 7, 2006)

say that word. It's the ugliest word in the English language, but that's what I see now—niggas," his character said.[234] Al Sharpton demanded the Cartoon Network pull the episode and apologize, claiming it desecrated Martin Luther King's image, but the network defended the show because of its thought provoking satire. Al Sharpton, the race-baiting extraordinaire, does anything he can to get his name in the news, often pretending to be outraged over issues he can use to weasel his way into the spotlight time and time again.

BET functions to keep its audience mentally enslaved, or "on the plantation," as many blacks say, and follows perfectly in line with what George Orwell warned about in *Nineteen Eighty-Four*, where he wrote, "Heavy physical work, the care of home and children, petty quarrels with neighbors, films, football, beer, and above all, gambling filled up the horizon of their minds. To keep them in control was not difficult...All that was required of them was a primitive patriotism which could be appealed to whenever it was necessary to make them accept longer working hours or shorter rations. And when they become discontented, as they sometimes did, their discontentment led nowhere, because being without general ideas, they could only focus it on petty specific grievances."[235]

Orwell explained, "All the beliefs, habits, tastes, emotions, mental attitudes that characterize our time are really designed to sustain the mystique of the Party and prevent the true nature of present-day society from being perceived."[236]

[234] *Cartoon Network* "The Boondocks: Return of the King" (2006)
[235] Orwell, George - *Nineteen Eighty-Four* page 63
[236] Orwell, George *Nineteen Eighty-Four* page 187

In other words, the garbage aired on BET keeps people occupied and entertained with mindless nonsense, preventing them from actually contemplating or even being aware of issues and events that actually matter. "Left to themselves," Orwell said, "they will continue from generation to generation and from century to century, working, breeding, and dying, not only without any impulse to rebel, but without the power of grasping that the world could be other than it is."[237]

[237] Orwell, George *Nineteen Eighty-Four* page 187

Pop Music

We have come to expect satanic imagery and socially destructive themes in heavy metal, rock and roll, and in recent years it's become fairly well known that rappers have also pushed Illuminati and satanic propaganda—but female pop stars and teen idols doing it is something totally new. These pop stars I'm speaking of aren't fringe "Goth chicks" or singers from rebellious female heavy metal or rock bands, but instead are household names held up as role models and idols by their legions of largely preteen fans. These singing strippers and satanic skanks spew their sick songs into the minds of millions of impressionable children who practically mimic their every move.

Adam Weishaupt, the founder of the Bavarian Illuminati, who organized and modernized the goals and operations of the corrupted ancient Mystery Schools, wrote, "There is no way of influencing men so powerfully as by means of the women. These should therefore be our chief study; we should insinuate ourselves into their good opinion, give them hints of emancipation from the tyranny of public opinion, and of standing up for themselves; it will be an immense relief to their enslaved minds to be freed from any one bond of restraint, and it will fire them the more, and cause them to work for us with zeal, without knowing that they do so; for they will

only be indulging their own desire of personal admiration."[238]

Today's Illuminati posing female pop stars appear on morning talk shows like *The Today Show*, *Good Morning America*, and afternoon shows like *Ellen*, not to mention they're regular fixtures on MTV and appear in countless commercials for beauty products and high fructose corn syrup flavored water—known as "soda" to most people—the cavity causing crap in a can that's basically a staple in most American's diets.[239]

These same pop stars are the people preaching perverted messages to young girls and teaching them to be dumb, drunk sluts, and deceiving them into believing they have nothing to offer the world other than what's between their legs. Nicole Sherzinge, former lead singer of the Pussycat Dolls, admitted, "To make it, you really have to sell your soul to the devil."[240]

They don't call Hollywood the city of broken dreams for nothing, because the industry preys on people so desperate for fame that they will do literally anything for a chance to be in the limelight. In a revealing interview on *Inside the Actors Studio* about why he stepped out of the limelight at the height of his career, Dave Chapelle called the entire Hollywood environment "sick." Let's now take a look at some of the most famous female artists in the world, and see how they too have

[238] Robison, John – *Proofs of a Conspiracy* p. 111

[239] Most soda brands don't use sugar anymore, and instead use high fructose corn syrup as a substitute to obtain the sweetness that so many people guzzle on a daily basis.

[240] *The Independent* "What's new Pussycat? Nicole Sherzinger on being a global pop star and conquering an eating disorder" (March 10th 2013)

obviously sold their souls to Satan and become pushers of some of the most putrid propaganda the world has ever seen.

Beyoncé

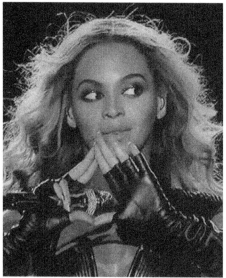

PHOTO: The CBS NFL Super Bowl Half Time Show in February 2013, where Beyoncé made this mysterious hand sign during her performance.

Beyoncé Knowles (known simply as Beyoncé) rose to superstardom as the lead singer of the girl group Destiny's Child, and later broke away for a solo career and

hooked up with Jay-Z, marrying him in 2008, after he proposed with a five million dollar engagement ring.[241]

Beyoncé and Jay-Z were ranked the most powerful couple in *TIME* magazine's 100 most influential people list in 2006, and the two stayed on the list for years, even landing Jay-Z on the cover of the magazine in 2013.[242] *Forbes* ranked them as the highest earning couple in Hollywood in 2009, estimating their income for the year at $162 million,[243] and the following year they topped the list again, pulling in $122 million.[244] In January 2012, Beyoncé gave birth to their daughter, named Blue Ivy Carter, sparking numerous rumors about the baby's name possibly holding a secret Illuminati meaning.[245] One popular allegation was that Ivy stood for *Illuminati's Very Youngest*, a pretty ridiculous claim, but perhaps not as ridiculous as naming your child "Blue!"

Let's take a look at Beyoncé's dark transformation from an innocent singing sweetie pie, to an Illuminati symbol spewing witch, culminating in her 2013 Super Bowl Halftime performance where she flashed Jay-Z's trademark "Illuminati" gesture to the camera by joining her index fingers and thumbs into a triangle for a brief moment. My YouTube video about this event received over one million views and "Beyoncé Illuminati" trended

[241] *People Magazine* "Beyoncé Shows Off $5M Wedding Ring" by Antoinette Y. Coulton (09/06/2008)

[242] *Time Magazine* "Times 100 Most Influential People" (April 2013)

[243] *Forbes* "Hollywood's Top-Earning Couples" by Lacey Rose (11/19/2008)

[244] *Forbes* "Hollywood's Top-Earning Couples" by Dorothy Pomerantz (1/12/2010)

[245] *Washington Post* "Beyonce's baby: Blue Ivy and what's in her name" by Jen Chaney (01/09/2012)

on Twitter and Yahoo, indicating many people were becoming privy to such symbols.

Beyoncé's descent into the dark side appears to be directly related to her relationship with Jay-Z, who many people believe exposed her to the Secret Doctrine. For example, the once sweet and innocent Beyoncé is "killed" by Jay-Z in a fiery explosion in her "Crazy in Love" music video, which shows Jay-Z purposely starting the fire that blows up Beyoncé's car as she's trapped inside, and then her alter ego "Sasha Fierce" is born and rises out of the ashes, popping back on screen dancing next to Jay-Z. The scene appears to be a deliberate symbolic "killing off" of the old Beyoncé, and depicts the birth of "Sasha Fierce," her strange and satanic looking alter ego.

Beyoncé then appeared on stage at the 2007 BET Awards dressed as a robot depicting "Sasha Fierce" that looked identical to the satanic robot in the popular 1927 German film *Metropolis*, a classic movie about a wealthy ruling elite and the poor underclass slaves who must work tirelessly to support the lifestyle of their masters. Not long after that, Beyoncé performed at the 2010 Grammies along with dozens of dancers dressed in police riot gear that escorted her on stage and then joined in her performance. The bit was designed to make police in riot gear seem sexy and cool, and served to promote the Police State America was becoming as a result of the War on Terror and our shrinking liberties.

Following her Grammy performance came the biggest moment in her career when Beyoncé headlined the Super Bowl Halftime Show in February of 2013, the biggest gig for any performer, where she threw up Jay-Z's triangle Illuminati-looking hand sign, sparking headlines around the world. Yahoo Sports covered the wave of

rumors and online comments about the gesture,[246] Glenn Beck's news outlet *The Blaze* published an article on the speculation,[247] and James Manning, an outspoken African American pastor, ranted about "Beyoncé the booty shaker" and called her a "witch."[248]

If the hand sign is just a diamond and symbol of Roc-A-Fella records, then why does Jay-Z always look through it with one eye? He and Beyoncé surely must know that an eye inside a triangle is a Masonic and Illuminati symbol, yet they continue to use it on a regular basis.

After her halftime performance, a TMZ videographer caught up with music mogul Russell Simmons and asked him about the Beyoncé Illuminati rumors, to which he answered, "Everybody who works hard, looks inside themselves, finds strength, creates something special—the president, Jay-Z, you know, who ever does well—whoever realizes their potential—it makes people who don't work or don't have faith or confidence or courage to be good or be great to point the finger, and they gotta say, this nigga—homes is down with the Devil."[249] When the paparazzi then asked him if he believed in the Illuminati he replied, "Are you fucking kidding me? I'm a grown man, of course not."[250]

Simmons' Def Jam Records has signed such scumbag artists as Rick Ross, Rihanna, Lady Gaga and

[246] *Yahoo Sports* "Did Beyonce flash an Illuminati sign?" by Jay Busbee (February 4, 2013)

[247] *The Blaze* "Did Beyoncé Flash an Illuminati Symbol During Super Bowl Halftime Show?" (February 4, 2013) by Liz Klimas

[248] *YouTube.com/ATLAHWorldwide* "Beyonce Ain't no Billie Holiday" (February 2nd 2013)

[249] *TMZ* "Russell Simmons: The Illuminati Doesn't Exist" (2-7-2013)

[250] Ibid

other mainstream stars. In 2004, Russell Simons bought Jay-Z's Roc-A-Fella Records for $10 million dollars and made Jay-Z the CEO.[251] Simmons personal net worth has been estimated to be around $340 million dollars,[252] making him one of the richest men in hip hop.

What makes Beyoncé's transformation from a sweetheart to a Baphomet bottom feeding bimbo even more disappointing is the fact that the name of her girl's group "Destiny's Child" was chosen by her mother while she was reading the Bible after the two words jumped out at her and she felt it was a sign from God as to the name for her daughter's group.[253]

[251] *MTV.com* "Jay-Z, Dame Dash Sell Roc-A-Fella Records; Jay Named Def Jam Prez" by Rashaun Hal (Dec 8, 2004)
[252] *CNN* "Russell Simmons: Getting rich is so simple" by Tania Padgett (April 26, 2011)
[253] *MTV.com* "Destiny's Child's Long Road To Fame" by Gil Kaufman (June 13, 2005)

Rihanna

PHOTO: Rihanna's music video "Rock Star," where she appears to be dancing on the floor inside an occult symbol, while wearing horns on her head.

Singer and pop star "Rihanna" (whose real name is Robyn Rihanna Fenty) became one of the most popular stars in the world after signing a record deal with Def Jam records after auditioning for Jay-Z. *Forbes* reported she earned $53 million dollars in just one year[254] and *Time* magazine has also ranked her one of the most influential celebrities in the world.[255] She has also, unfortunately, become one of the most infamous "Illuminati puppets" in the music industry.

Rihanna had a clean image for her first two albums, and then in 2007 she took a turn for the worse with her third album *Good Girl Gone Bad*, clearly announcing her metamorphosis to a more demonic singer,

[254] *Forbes* "The World's 25 Highest-Paid Musicians of 2012"
[255] *Time Magazine* "The World's 100 Most Influential People: 2012" by Stella McCartney (April 18, 2012)

and it was all downhill from there, ultimately leading her
to embrace the title of "Illuminati Princess."

In her songs, music videos, and through social
media, she has promoted sadomasochism, doing drugs,
and some even say suicide because of her song "Russian
Roulette," where she sings to "Take the gun, and count to
three, I'm sweating now, moving slow, no time to think,
my turn to go." Because she was discovered and had her
image crafted by Jay-Z, this should come as no surprise.

For example, in her music video for "Rock Star"
she is shown in one scene dancing on the floor on her
hands and knees inside a circle containing two
intersecting triangles while wearing what many say are
"devil horns" or a Baphomet headdress. The circle
painted on the floor looks similar to a satanic pentagram,
which is often drawn on the floor and used in black magic
rituals. Why would anyone wear what looks to be devil
horns and dance inside what looks to be an occult symbol
painted on the floor unless they were trying to convey the
message that they were some kind of black magic
practitioning witch? How could this scene be interpreted
any other way?

In another one of her videos, titled "S&M" (short
for sadomasochism) it shows Rihanna tied up in latex
bondage looking like she's, in my opinion, about to get
gangbanged on a dirty mattress by a bunch of dudes under
a wall of Big Brother cameras watching the whole thing.
This is the kind of satanic and skanky behavior the
Illuminati want your children to mimic and the kind of girl
they want them to look up to.

Another scene from "S&M" shows a headline
scrolling past the screen reading "Princess of the
Illuminati." Rihanna's Illuminati affiliations seem to go
on and on with events like her performance on *American*

Idol where she appeared on stage inside a pyramid,[256] and the cover art for her single "Diamonds" includes a human skull. The song features Kanye West who raps a line about the Illuminati and high society.

Rihanna's infamous on-again-off-again boyfriend, R&B singer Chris Brown, best known for beating the crap out of her in a brutal assault before of the 2009 Grammies, launched an Illuminati-looking clothing line in 2012 called Black Pyramid, which features—you guessed it—a black pyramid as the logo. Perhaps Chris Brown is yet another Illuminati poser or trying to cash in on the Illuminati infestation happening in hip-hop, or perhaps he was trying to impress Rihanna, the "Illuminati Princess," with his own Illuminati associations.

Brown said of his fashion venture, "The black pyramid label is basically an unknown art. We really haven't mastered the art of making a pyramid ourselves, like the ancient ones, so it's kinda like an unknown art. So I think my painting, my designs, whatever I do fashion wise is unknown to a lot of people"[257] In 2012 Chris Brown tweeted out a photo showing off his new tattoo of a snake shedding its skin, and instead of a rattle at the end of the snake's tail, it had an Illuminati All-Seeing Eye within a triangle. The tattoo is enormous, taking up virtually one third of the singer's back.

[256] *American Idol* "Rihanna performs her hit, 'Where Have You Been' at the Season 11 Finale"
[257] *939Kissfm.com* "Chris Brown Creates Rih-Rih & Breezy Shirt For His Clothing Line Black Pyramid"

Nicki Minaj

PHOTO: Nicki Minaj performs her song "Roman Holliday" at the 54th Annual Grammy Awards in February 2012 on CBS.

One of the biggest bottom feeders in the industry is Nicki Minaj, a stage name short for *minajatwa*, meaning "Nicki Threesome," who came on the scene after getting signed to Lil Wayne's label, Young Money Entertainment. Like other Baphomet bimbos, she's done a Pepsi commercial pimping out their product to the pathetic Pavlovian soda slurping suckers who will be more inclined to drink the garbage since she promotes it. This vocal virus was also included in the 2012 Super Bowl Halftime Show featuring Madonna, which was more like an elaborate Illuminati ritual than a halftime show. This ghoul has also appeared in living rooms across the country as a judge on *American Idol*, the show where more Americans cast their votes than in a presidential election.[258]

[258] *The Guardian* "American Idol outvotes the president" by Mark Sweney (May 26, 2006)

While Nicki "Threesome" Minaj is adored by little girls around the world, the content of her music couldn't be more demonic. In fact, she claims to be possessed by an evil spirit of a little boy named Roman Zolanski, who may be named after Roman *Polanski*, the director of *Rosemarie's Baby*, an atrocious film about Satan raping a woman in order to impregnate her with the antichrist. Roman Polanski, the film's director, was charged with the statutory rape of a 13-year-old girl (when he was 45) and fled the country to avoid prison time,[259] yet is still loved by the Hollywood elite, even winning several Oscars and Golden Globe Awards.[260] Is Nicki Minaj's alter ego "Roman Zolanski" named after Roman Polanski? Many believe the answer is yes.

At the 2012 Grammies, Nicki "Three-way" performed her song "Roman Holiday" in a skit so bizarre it left much of the audience wondering what they had just watched. Earlier she had arrived at the Grammys dressed as a demonic nun escorted by an old man dressed as a priest. The name of her song "Roman Holiday" also has sinister meanings, referring to "a time of debauchery or of sadistic enjoyment."[261] Just a sample of the lyrics go like this: "I'm a bad bitch, I'm a cunt and I'll kick that hoe, punt. Forced trauma, blunt. You play the back, bitch, I'm in the front."

Talk show host Ellen DeGeneres (often called Ellen *Degenerate* by her critics) once had two little girls on her show, Sofia Grace (age eight) and her cousin Rosie

[259] *Daily Mail* "French government drops support for director Roman Polanski as he faces extradition to the U.S." by Peter Allen (October 1st 2009)
[260] *IMDB* "Awards for 'The Pianist'" (2002)
[261] Merriam Webster Dictionary definition

(age five), who Ellen proudly introduced as Nicki's biggest fans, and then surprised them by bringing Nicki "Minajatwa" on the show to meet them. "I want your new album," one of the girls screamed as she jumped up and down in delight.[262] The brain dead audience was so moved, many of them were in tears—not crying because Ellen introduced this demon to these poor misguided children, but because they were so happy that she did. The songs contain such filth that only a grossly irresponsible or demented parent would dare expose their daughters to her.

Nicki's image seems specifically designed to appeal to children because her persona and style is that of a living doll, and she has made several suggestions that she's bisexual as well, which she later admitted were just attempts to get attention.[263] Of course she's in an industry of phonies and frauds but the one thing that's not a mirage is that Nicki Minaj is dirtier than a garage but still the zombies applause.

> Ok first things first I'll eat your brains
> Then I'ma start rocking gold teeth and fangs
> Cause that's what a muthafucking monster do
> *-Monster*

[262] *Washington Post* "Nicki Minaj performs with tiny 'Super Bass' video stars on 'The Ellen DeGeneres Show'" (10/13/2011)
[263] *The Advocate* "Nicki Minaj Admits She Lied About Being Bisexual" by Diane Anderson-Minshall (September 5, 2012)

Lady Gaga

One of the first female pop stars to be accused of supposed ties to the Illuminati is Lady Gaga, who appeared on the scene in 2008 with her bisexual themed single "Poker Face," a song about being in the company of a man, but fantasizing she was with a woman instead, hence having to use her "poker face" so the guy wouldn't think something was wrong.[264] Lady Gaga (or Lady Caca or Lady Gag Me, as I like to call her) was basically a reincarnation of the 1980s Madonna and did just about anything for attention, including wearing her infamous "meat dress" to the 2010 *MTV Video Music Awards*.

Gaga is often photographed wearing costumes using All-Seeing Eye symbolism and has been a very vocal supporter of homosexuality and admitted to Barbara Walters that she has had sex with women and is bisexual.[265] Her 2011 song "Born This Way" was described as an anthem for the gay community, and in a *Saturday Night Live* skit she sung about banging two guys at the same time.[266] While on the *Jimmy Kimmel Show* she told a story about recording songs on her tour bus and how she "swore to Lucifer" that she would kill her crew if they couldn't make the equipment work properly.[267] She refers to her fans as "monsters" or "little monsters," which

[264] *NBC Bay Area* "Lady GaGa Entertains Thousands At Palm Springs White Party" (April 14, 2009)
[265] *ABC News* 20/20 "Barbara Walters Most Fascinating People of 2009" (2009)
[266] *NBC* "Saturday Night Live: Digital Short: 3-Way (The Golden Rule)" (May 21, 2011)
[267] *ABC* "The Jimmy Kimmel Show" Interview with Lady Gaga

is actually an appropriate title for the lost and decadent souls who support Gaga.

Gaga revealed to Howard Stern that in her early twenties, before she became famous, she would lock herself inside her New York apartment and snort cocaine all alone while playing the piano and writing music, calling the drug her "friend."[268]

Like many people who have sold their soul for mainstream success, she is haunted by nightmares, something that few other stars will talk about. She told *Rolling Stone* magazine, "I have this recurring dream sometimes where there's a phantom in my home. He takes me into a room, and there's a blond girl with ropes tied to all four of her limbs. And she's got my shoes on from the Grammys. Go figure—psycho. And the ropes are pulling her apart."[269]

She continued, "I never see her get pulled apart, but I just watch her whimper, and then the phantom says to me, 'If you want me to stop hurting her and if you want your family to be OK, you will cut your wrist.' And I think that he has his own, like, crazy wrist-cutting device. And he has this honey in, like, Tupperware, and it looks like sweet-and-sour sauce with a lot of MSG from New York. Just bizarre. And he wants me to pour the honey into the wound, and then put cream over it and a gauze."[270]

She stated in the interview that her mom said it was an Illuminati ritual and that she decided to incorporate

[268] *New York Post* "Lady Gaga on her cocaine use: 'The drug was my friend'" (May 4, 2012)
[269] *MTV.com* "Lady GaGa: 'Isn't That An Illuminati Ritual?'" (June 28, 2010)
[270] Ibid

it into her shows, because, "A lot of the work I do is an exorcism for the fans but also for myself."[271]

She once simulated her own death on stage during a performance of her song "Paparazzi" at the *MTV Video Music Awards*, and after staying in the luxury Intercontinental Hotel in London, several maids reportedly found what looked like blood covering the entire bathtub, leading one housekeeper to claim Gaga was "bathing in blood as a Satanic ritual."[272]

One maid said after she reported the incident to the concierge they told her to "put it out of her mind." Another worker claimed, "All of the hotel's staff are convinced she was bathing in it or, at the very least, using it as part of one of her new costumes or weird stage routines."[273]

Lady Gaga also hoped to display actual dead bodies on stage during her concerts and reached out to the creators of the Body Worlds exhibit which featured actual human bodies in various states of dissection to show the muscle structures for scientific study. Gaga apparently thought adding actual human corpses as decorations would be something cool to include at her concerts.[274] After word spread about her morbid dead body dreams and many people expressing their disgust, she quietly abandoned the idea.

At one point in time, Lady Gaga held the world record for the most Twitter followers[275] with over 39

[271] Ibid
[272] *The Daily Telegraph* "Lady Gaga in Satanic blood bath claim" (January 04, 2012)
[273] Ibid
[274] *The Sun* "Lady GaGa's Auopsy" (June 23rd 2010)
[275] *Forbes* "Lady Gaga's Newest Record: 15 Million Twitter Followers" (10/28/2011)

million morons following the creature,[276] sadly showing the extraordinarily high number of idiots who are interested in this evil Illuminati icon. The fact that this clown-faced freak is adored by so many people is a reflection of our sick and satanic society that simply swallows whatever the mainstream is selling and believes it's creative and cool.

Kesha

PHOTO: Kesha in her music video "Die Young' dancing in front of a pentagram on the wall inside of a church.

One of the most blatant satanic singing serpents who—in my opinion—looks like a heroine addicted, herpes infested hooker from hell, high on crystal meth, is Kesha (styled with a dollar sign as Ke$ha)—a trailer trash looking tramp with no talent, who is her generation's token white trash witch of the music industry—whose

stench has spread around the world into the minds of millions.

Kesha, whose mother reportedly doesn't know who fathered this creature,[277] has made Aleister Crowley proud by promoting Satanism to her 25 million Facebook fans, many of whom are impressionable preteen girls. I don't even know where to start with this sewage smelling scoundrel because she's done so many bizarre things it's hard to keep up with them all.

To begin with, she drinks blood out of a heart on stage and drips it all over her face and chest;[278] she drank her own urine on her MTV show *My Crazy Beautiful Life;*[279] she has posted pictures of herself wearing satanic pentagram jewelry on her Facebook page; she asked her fans to send her their teeth which she then used to make a bra and head dress out of the one thousand teeth she received from her deranged fans [280] (which she calls Animals); she claims to have had sex with a demon or a ghost;[281] she wore an upside down crucifix on her leotard when performing live on *The Today Show*—while at the same time her backup dancers had Illuminati All-Seeing Eyes incorporated into their costumes;[282] in her video for "Die Young" she and her friends have an orgy inside a

[277] *MIX96 KYMX* "6 Crazy Facts About Ke$ha" (April 15, 2013)

[278] *NME.com* "Ke$ha 'drinks blood from a heart' in Sydney stunt" (March 16, 2011)

[279] *New York Daily News* "Ke$ha reveals she drank her own urine in an effort to 'be healthy' in MTV documentary 'My Crazy Beautiful Life'" by Zayda Rivera (February 14, 2013)

[280] *MSN* "Only Ke$ha is creepy enough to make her bras out of fans' teeth" (11/23/2012)

[281] *MSN* "Ke$ha reveals she's had ghost sex; celebrity gossip hits weird new low" (9/27/2012)

[282] *The Today Show* (November 20, 2012)

church after she arrives in a hearse that has the word "evil" written on the back;[283] she sings about serial killer Jeffrey Dahmer and cannibalism; she took dozens of pictures of guys' penises as a condition before allowing them on her tour bus to meet her and hang out;[284] she encourages one night stands (even has a song titled "Booty Call"); and that's just a sample of what this trash can contains.

Kesha is a perfect example of what the Illuminati wants your little girls to grow up to be like. She's a Jack Daniel's guzzling, blood drinking bimbo who doesn't have a care in the world about anyone or anything other than getting wasted, getting laid, and getting rich.

This witch has tossed condoms to her fans that feature her face on the wrappers, and said "I knew everything about sex before I was even seven. My mom left me at home when I was 14 with a credit card, and a box of condoms and the keys to the car."[285] Sounds like she had a very irresponsible mother, and the rotten apple didn't fall too far from the tree.

While talking with Ryan Seacrest on his KISS FM radio show, Kesha revealed her album *Warrior* was the result of a recent spiritual journey she took, and that, "The theme of this record is magic. I went on a spirit journey by myself, no security guard, no managers. I just went around the world and lived on a boat…I went diving with great white sharks, and just went on this crazy spirit quest…It's about experiences with the supernatural… but

[283] *New York Daily News* "Ke$ha's 'Die Young' pulled off radio after Sandy Hook Elementary School shooting" by Rheana Murray and David Hinckley (December 18th 2012)
[284] *CMU* "Ke$ha removes revealing fan photos from memoirs on legal grounds" (December 10, 2012)
[285] *New York Daily News* "Ke$ha: 'I knew everything about sex before I was even seven' by Shari Weiss (January 18, 2011)

in a sexy way...I had a couple of experiences with the supernatural."[286]

One of these "experiences" she says, includes having sex with a ghost. "I don't know his name! He was a ghost! I'm very open to it...There are so many weird topics on this record...from having sexy time with a ghost to getting hypnotized and going into past lives. I just really wanted the theme of this record to be the magic of life."[287]

Kesha, more than any other pop star, took her satanic symbolism to a new level by posting upside down pentagrams on Facebook and including the images seen in her music videos, leaving no question as to her spiritual beliefs. What's even more disturbing is that mainstream shows like *The Today Show*, Nickelodeon's *Kids Choice Awards*, *Ellen*, and countless others promote her with a smile as if she's the girl next door.

> I don't really care where you live at
> Just turn around, boy, let me hit that
> Don't be a little bitch with your chit chat
> Just show me where your dick at
> -*Blah, Blah, Blah*

[286] *RyanSeaCrest.com* "WORLD PREMIERE: Listen to Ke$ha's New Single 'Die Young' [AUDIO]" (September 25, 2012)
[287] Ibid

Miley Cyrus

PHOTO: Miley Cyrus at the MTV Video Music Awards in 2013.

Another child star turned "Disney Devil" is Miley Cyrus, who desperately tried to destroy her family friendly "Hanna Montana" image while launching her post-Disney singing career with what she hoped to be an anthem for teenage rebellion. Her music video "We Can't Stop" was so over-the-top that many fans commented they "Miss the old Miley" and the video received nearly a 50% thumbs down rating on YouTube.

In the video, a butch looking Miley is shown fondling herself as she sings about "waiting in line at the bathroom, *trying to get a line* in the bathroom" referring to what appears to be a reference about snorting cocaine as is known to happen fairly frequently in the bathroom at parties and clubs. There is an admitted drug reference at another point in the song when she sings about "Dancing with Molly," a slang term for partying on MDMA, the active ingredient in ecstasy. The song's producer initially denied that's what she was saying, insisting the lyric is "dancing with *Miley*," but a few weeks later Miley

admitted, in fact, she was singing about ecstasy. "If you're aged ten [the lyric is] Miley. If you know what I'm talking about then you know. I just wanted it to be played on the radio and they've already had to edit it so much," she said, adding, "I don't think people have a hard time understanding that I've grown up. You can Google me and you know what I'm up to—you know what the lyric is saying."[288]

There's also a line about how "we can screw who we want," referring to casual sex.[289] The video also reveals Miley has a tattoo of an All-Seeing Eye on one of her fingers, and the entire video appears to be a group of teenagers partying in a house while their parents are gone.

Miley "Virus," as I call her, made headlines around the world after her 2013 MTV VMA performance where she had her hair made up into what looked like devil horns and put on a performance so crude it even shocked many of the celebrities in the audience. She was fondling herself, twerking with Robin Thicke, and kept sticking her tongue out and making faces like a ravenous dog. To make it even worse, her backup dancers were dressed as teddy bears in what appeared to be an attempt to appeal to small children from her Hannah Montana fan base.

Miley "Virus" is a coming of age mess, and a butch-looking blabbermouth bimbo whose rebellious streak is painful for many of her fans who are disappointed to see her turn her back on the family friendly "Hannah Montana" they knew and loved.

[288] *New York Daily News* "Miley Cyrus admits to making drug reference in 'We Can't Stop': 'You know what I'm up to'" by Chiderah Monde (July 22, 2013)
[289] *RockGenius.com* "Miley Cyrus: We Can't Stop (Lyrics)"

Justin Bieber

PHOTO: Instagram: Justin Bieber's "eye believe" tattoo.

Believe it or not, the seemingly squeaky-clean teen idol Justin Bieber is also linked to Illuminati allegations. Bieber came onto the global stage looking like an anorexic, estrogen overdosed, emaciated feminine pop star with the voice of a 12-year-old girl in 2010, and became one of the most famous performers in the world.

At the time of this writing he's still a teen, smoking pot, drinking underage, and speeding around town in his fancy cars, but his music is fairly innocent compared to others, although that's likely to change in the future when he'll probably try to make a controversial comeback after his limelight fades, reinventing himself like so many child stars do, trying to shed the family friendly image that propelled them to become a pop star in the first place.

Part of his early attempts to break away from his child star image have been getting some "ink" including a strange owl tattoo on his forearm that looks an awful lot

159

like the mascot of the Bohemian Grove, the secretive men's club where the superclass hang out every July for off-the-record Lakeside Talks and perform their annual Cremation of Care human sacrifice ritual where a life-size effigy of a person is burned on an alter in front of a 40-foot tall statue.

At a Victoria Secret fashion show he was asked about his owl tattoo and what it means, and he reluctantly answered, "Um…it means a lot of different things, but, uhh, it's what's important to me, I don't think—it's not really for other people to really know about."[290]

It's interesting that shortly before he got his owl tattoo he was admiring a tattoo on the forearm of a British television host on BBC Radio 1 and Bieber asked him if he was a member of the Illuminati. It appears he may have been inspired by the host's "Illuminati" tattoo, and then decided to get one for himself. The following year he got another bizarre tattoo, this time of a huge eye on the inner crease of his elbow, and in the caption on the Instagram photo he posted, he said it was his mom's eye and that she's "always watching." Very odd, indeed.

Time will tell if Justin Bieber's star will fade and if he'll attempt to revive his career with an absurd envelope-pushing publicity stunt, or if he'll become a victim of drug abuse under the pressure of being one of the most popular stars of his time as has been the fate of so many before him.

[290] *Eonline.com* "The Biebs Hits Victoria's Secret Fashion Show 2012"

Madonna

PHOTO: Madonna performs during the NBC NFL
Super Bowl Halftime Show in 2012.

The "Material Girl" Madonna burst onto the scene
in the 1980s with her bleach blonde hair and bold sexual
themed songs, securing her a virtual lifetime membership
in the limelight of the entertainment industry's hall of
fame. As the 1980s and 90s passed, Madonna was
replaced by newer, younger stars like Britney Spears and
Christina Aguilera, but Madonna never really went away,
and occasionally reared her aging head from time to time
and is always welcomed by the media and her dedicated
fans.

Over the decades she made headlines for various
controversies from Christianity bashing, to her
involvement with the Kabbalah, a form of Jewish
mysticism often associated with the Illuminati, and later in
life while in her mid-50s she was still prancing around on
stage dressed like a 20-year-old, even pulling down her

pants and flashing her granny butt to audiences,[291] apparently not realizing the 1980s had long since passed.

Madonna appeared in center stage again when she headlined the halftime show of the 2012 Super Bowl, where her act was more like an elaborate Illuminati ritual, than a musical performance. It was a bizarre Egyptian themed showcase that cast her as the high queen, wearing a crown with devil horns coming out of it. The performance was so strange that Illuminati rumors began circulating on the Internet in record number, with many viewers unfamiliar with the Illuminati or occult symbolism even wondering what they had just witnessed, sensing something was wrong and feeling the unusual performance held some secret meaning.

There was plenty of sun symbolism and religious pageantry throughout the performance, and at the time, it was the biggest Super Bowl halftime show in history and introduced Madonna to a whole new generation of people who didn't really know anything about her from her heydays back in the 80s.

In a post-performance interview about the show, she was seen wearing skull and crossbones earrings, adding to the controversy, and sparking even more Illuminati rumors by people believing the jewelry was a veiled shout-out to her Illuminati masters since they were the same symbol as the infamous Skull and Bones society, founded back in 1832 as the American branch of the Illuminati by William Huntington Russell after he returned from Europe with authority to expand the Illuminati's influence in America.

[291] *Hollywood Reporter* "Madonna Moons the Audience During Her Rome Concert (Video)" by Elizabeth Snead (6-13-2012)

Several years earlier when Janet Jackson had her "wardrobe malfunction" causing her bare breast to be revealed to the millions watching, Janet was wearing an Illuminati sun symbol nipple ring, causing some to think the whole "wardrobe malfunction" claim was a cover story for a purposefully designed stunt aimed at showing nudity to the record live audience.[292]

In the meantime, Madonna is apparently desperately searching for the fountain youth as she continues to age, trying to maintain the image she built her entire career upon. It has even been claimed that she sleeps with her body covered in anti-wrinkle cream while wearing a plastic body suit to keep the cream from soiling her bed sheets, allegedly in hopes of preventing wrinkles.[293] Knowing just how far many celebrities are willing to go in hopes of preserving their pretty past, nothing these narcissists do should surprise you.

Madonna is also the celebrity face of Kabbalah, which is a Jewish esoteric mystic philosophy claiming to contain the elite secrets of our true nature and power as humans and teaches people how to allegedly connect with the Divine and elevate themselves to higher levels of consciousness, power, and success. Madonna is at the top of a long list of celebrities who have publicly supported the controversial Kabbalah Center in Los Angeles, which is dedicated to promoting these occult ideas. The center, which is a tax exempt organization, has been labeled a religion for profit by critics and it was

[292] *CBS News* "Janet's Bared Breast A PR Stunt?" (December 5, 2007)
[293] *Mirror* "Madonna's £562,600 regime to look young" (July 6th 2010)

once investigated by the IRS for financial mismanagement.[294]

Ashton Kutcher, Demi Moore, Lucy Liu, Anthony Kiedis of the Red Hot Chili Peppers, Mick Jagger of the Rolling Stones, Britney Spears, Paris Hilton, and many more have all dabbled in Kabbalah for a while at one point or another, but Madonna seems to have stuck with it for the long run. Madonna has proudly worn a red string bracelet and other Kabbalah symbols, and even quit putting on concerts on Friday nights because of Shabbat, the Jewish day of rest similar to the Sabbath, which begins at sunset on Friday night and is observed until Saturday night.

She kicked off her 2012 MDNA tour in Tel Aviv, Israel and described it as "the journey of a soul from darkness to light." She named her album (and tour) after MDMA, the active chemical in the drug ecstasy, as an attempt to be trendy and cool by appealing to all the pill popping partiers she wants to dance to her music. She erased all doubt about promoting the club drug when she addressed the crowd at the Ultra Music Festival in Miami, asking, "How many people in this crowd have seen Molly?"[295] Molly, of course, the slang term for ecstasy or MDMA.

Popular DJ and producer Deadmau5 blasted Madonna for blatantly promoting the drug. "Very classy there Madonna. HAS ANYONE SEEN MOLLY??? Such a great message for the young music lovers at ultra.

[294] *Los Angeles Times* "The Kabbalah Centre in Los Angeles is the focus of an IRS investigation into tax evasion" by Harriet Ryan (May 06, 2011)
[295] *MTV.com* "Madonna Makes Peace With Deadmau5 After Ultra 'Molly' Comments" by Gil Kaufman (March 27, 2012)

Quite the philanthropist. But hey, at least your HIP AND TRENDY!"[296]

When she was promoting the album on *The Tonight Show* with Jay Leno, she admitted again, it was named after ecstasy. Jay asked her point black what the title meant, and she said, "Well, you've heard of this drug that produces euphoric feelings of love, MDMA. Have you ever tried it?" An uncomfortable Jay Leno replied "no, I haven't," and then moved on to his next question.[297]

[296] *Washington Post* "Madonna uses day on Twitter to settle beef with deadmau5" by Sarah Anne Hughes (03/27/2012)
[297] *ABC News* "Madonna Talks New Album and Super Bowl Performance on 'The Tonight Show'" (January 31, 2012)

Christina Aguilera

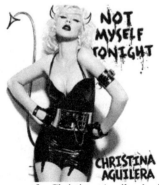

PHOTO: The cover for Christiana Aguilera's single "Not Myself Tonight," showing her with Devil horns and a Devil's tail.

Say it ain't so! Christina Aguilera is an Illuminati puppet too? Unfortunately—yes, and an obvious promoter of Satanism and debauchery as well. The former Mickey Mouse Club member came onto the music scene in 1999 with her hit "Genie in a Bottle," and instantly became a star—not only because of her cute looks—but because she has such an amazing voice which makes it especially heartbreaking to have to include her in the list of stupid singing skanks spreading Satanism.

Trying to shed her innocent girl next door image, she appeared onstage at the 2003 *MTV Video Music Awards* French kissing both Madonna and Britney Spears in a publicity stunt that made headlines around the world. But this would pale in comparison to the depths that she would sink to in the coming years when she started using Satanic imagery on her album covers, in her music videos, and even releasing a perfume named "Red Sin."

166

After four years without releasing an album she attempted to make a comeback in 2011 using bondage, sadomasochism and Satanism as her headline grabbing gimmick with her music video "Not Myself Tonight." The theme of the song and music video is that she's doing all kinds of crazy things as she has liberated herself from the social constraints of what society considers decent and normal. For example, she appears in the music video tied up and wearing a ball gag and other sadomasochistic gear; she crawls on the ground on all fours and eats from a doggie bowl, and if that's not bad enough, she and her friends are depicted having an orgy inside a Church which she then firebombs with a Molotov cocktail when they're done![298] The cover art for the single shows her with Devil horns and a Devil tail.

I'm kissing all the boys and girls
Someone call the doctor cuz I lost my mind
Cuz I'm doing things that I normally won't do
The old me's gone I feel brand new
And if you don't like it, fuck you
-*Not Myself Tonight*

[298] *MTV.com* "Christina Aguilera's 'Not Myself Tonight' Recalls Her 'Dirrty' Days" by Gil Kaufman (April 30, 2010)

167

Katy Perry

PHOTO: Screen shot from Katy Perry's hit "I Kissed a Girl."

Katy Perry burst onto the national music scene in 2008 with her hit single "I Kissed a Girl," a bisexual fantasy themed song that instantly secured her spot as an American idol, a song which was then sung by little girls around the world as they were introduced to the idea of sexually experimenting with their girlfriends by the newest rotten role model in music. Years earlier, in 2001, she had released a Christian gospel album, but when her career never took off, she had a dramatic change of tune. "I swear, I wanted to be like the Amy Grant of music, but it didn't work out, so I sold my soul to the devil," she candidly explained in an interview.[299]

She had found a new formula for success and it worked like a charm. Instead of being a one hit wonder and fading away within a few months, Katy Perry was able to secure a long term career in the mainstream (urine stream) music business, later marrying British shock comedian Russell Brand, a former heroin addict, in a

[299] *HipHollywood.com* "YouTube Presents: An Interview with Katy Perry"

Hindu ceremony in Rajasthan, India—a marriage that only lasted barely a year.[300]

Katy's father, who is a pastor at a Pentecostal church in Southern California, appealed to his congregation once asking them to please pray for his daughter, calling her a "Devil child" because she built her career by allowing herself to be pimped out, so to speak, by the entertainment industry.[301] *Sesame Street,* the popular children's program, pulled a segment from the show featuring Katy Perry after she showed up on set wearing what was described as too risqué of an outfit with her boobs popping out.[302] How on earth a producer from *Sesame Street* could have even considered her for the show is a whole other issue. Perhaps the producer was purposefully trying to introduce the "I kissed a girl" singer to young and impressionable children in order to further corrupt society and break down the family.

This "Devil child" proudly promoted Barack Obama for president, helping spread his false promises and Orwellian agenda to her fans and squeezed into a skin tight "Obama dress" for a performance just before the 2012 election, a dress that featured Obama's symbols and campaign slogans.[303]

Some of her fans point to her 2012 song "Wide Awake" as a signal the singer has woken up about her evil deeds and was plotting a new course, but the song was

[300] *US Weekly* "Katy Perry: Russell Brand Announced His Divorce Plans With a Text Message" by Nicole Eggenberger (June 18, 2013)
[301] *The Sun* "My girl Katy Perry is a devil child" by Pete Samson (May 2nd 2013)
[302] *ABC News* "Katy Perry Jokes About 'Sesame Street' Ban" (09/27/2010)
[303] *USA Today* "Katy Perry sports minidress with Obama campaign slogan" by Alison Maxwell (November 4, 2012)

most likely just another catchy tune designed for mainstream appeal using the generic theme of "waking up" since such a term had become popular. The writing credit lists Katy Perry and three, yes *three* other people who collaborated together to write the song.[304]

Most music listeners are unaware that mainstream musicians are largely "performers" who perform songs that are purchased by their record label with the goal of having it resonate with a large audience. The "artists" are literally vocal actors and actresses singing from a script as if the songs come from their own heart.

It's also extremely strange that despite being in her late twenties, Katy Perry has the demeanor and conversation skills of a child. It's as if she has never emotionally matured, and it may be interesting to note that her real name is actually Katy Hudson,[305] a name she stopped using after her failed gospel career when she reinvented herself catering to the corporate media monopoly knowing her new bisexual "I kissed a girl" gimmick would be accepted with open arms.

[304] Katy Perry, Lukasz Gottwald, Max Martin, and Cathy Dennis
[305] *ABC News* "Pastors' Daughter Turns Pseudo-Lesbian Pop Princess" by Sheila Maikar (June 27, 2008)

Ciara

PHOTO: Ciara in a snippet of "Super Turnt Up" wearing a Hermetic Order of the Golden Dawn jacket.

A singer and wannabe actress who got a taste of fame for a brief moment is Ciara Harris, known to some simply as Ciara, an attractive black girl who had a music video of hers play on MTV for a few months and then quickly faded away under the shadow of the industry's already favorite token black female artists, Beyoncé and Rihanna.

After several years of trying to keep her career afloat by performing small shows at little known venues, Ciara and her management team seemed to come up with a plan hoping to get her some headlines again, and by now I'm sure you can guess what their scheme was—become an Illuminati sellout too.

Adding a slight twist to the typical Illuminati posing, Ciara appeared in the previews of her music video "Super Turnt Up" and "Keep on Looking," wearing boots with "The Hermetic Order of the Golden Dawn" written prominently on them, a 19th century secret society

popularized by Satanist Aleister Crowley. The Golden Dawn supposedly taught members secret methods to communicate with what they called the "secret chiefs" who were said to be ascended masters living in another dimension who taught members the divine mysteries of the Universe.

Just around the same time Ciara's official YouTube channel posted teasers of her new music videos showing her in Golden Dawn regalia, she was photographed at an event wearing a Baphomet-looking blouse, in what can only be seen as a blatant cry for attention following in the footsteps of other artists who have adorned themselves with this same occult image.

Justin Timberlake

PHOTO: Justin Timberlake's video "Mirrors" shows a
mysterious All-Seeing Eye in the background.

Rising to superstardom in the 1990s as a member
of the boy band 'N Sync, and later launching a successful
solo career, Justin Timberlake slipped a little Illuminati
symbolism in his music video "Mirrors," a song on his
2013 album *The 20/20 Experience*, of which he
collaborated with Jay-Z on, who also joined him on tour.
During his dealings with Jay-Z, did he convince
Timberlake to slip in some subtle Illuminati symbolism in
his video? Many people believe that is the case.
Perhaps Timberlake, who sounds like he's had his
testicles removed, wanted to get people talking about his
new album and hoped he could jump on the Illuminati
bandwagon too.

It's interesting to note that Timberlake's career
was started by a convicted conman, Lou Pearlman, who
was sent to prison for duping people out of an estimated

$300 million dollars.[306] Pearlman was the man behind numerous multi-million dollar boy bands, including 'N Sync, the Backstreet Boys and O-Town—after becoming fascinated with the success of the New Kids On The Block and hatching his scheme and throwing his hat in the boy band ring.

Boy bands are a very strange and disturbing phenomenon in music, because in many cases the band members aren't "boys," but instead are grown men in their 30s, who sing love songs to their audience of predominantly preteen girls, pointing at them in the crowd and blowing them kisses. In one of 'N Sync's hit songs in the 1990s, Timberlake urged his listeners not to pay attention to Jerusalem or Bible prophesies, but instead just live for right now and not to worry about the consequences of your actions.

We don't need all these prophecies
Telling us what's a sign, what's a sign
Cause paranoia ain't the way to live your life from day to day
So leave your doubts and your fears behind
Don't be afraid at all
Cause up in outer space there's no gravity to fall
-*Space Cowboy*

[306] *Associated Press* "Boy band founder to plead guilty in $300M suit" (March 4th 2008)

Jennifer Love Hewitt

While numerous celebrities endure an array of salacious gossip, harsh criticism, and even Illuminati accusations, one mentally unstable woman took conspiracy theories way too far and began harassing Jennifer Love Hewitt, stalking her, making death threats, and even allegedly assaulting Jennifer Love Hewitt's mother! The actress, perhaps best known for her role in the *I Know What You Did Last Summer* teen slasher series, and more recently playing a prostitute in Lifetime's *The Client List*, was even tracked down and confronted at a red carpet event by her nemesis.

In 2002, the former social worker named Diane Napolis was arrested after confronting Jennifer at the Grammy awards and allegedly assaulting Hewitt's mother at a film premiere.[307] The woman accused Jennifer Love Hewitt and Steven Spielberg of using "cybertronic mind control technology" to harass her and control her thoughts, and believed they were part of a satanic conspiracy of gang stalking. The woman was charged with six felonies and then committed to a psychiatric facility.[308]

From the mid-1990s to 2000, the stalker Diane Napolis, accused various people in San Diego and San Francisco of Satanic ritual abuse against children and believed there was a powerful secret network of Satanists who abused children. Similar allegations have been

[307] *Sunday Mirror* "Spielberg Stalker in Mind-Bug Game" by MacKenzie, D (October 20, 2002).page 16.
[308] *Union Tribune* "Stalking suspect to undergo more psychological tests" by Mark Sauer (December 31, 2002)

made (although not accusing Jennifer Love Hewitt or Steven Spielberg of being involved) by former Senator John DeCamp, whose horrifying book *The Franklin Cover-Up* claims that a group of Satanists engaged in this type of abuse inside the Bohemian Grove in the 1980s, and even accused someone they called "Hunter Thompson" of shooting snuff films there.[309]

Many people believe this "Hunter Thompson" was a reference to Hunter S. Thompson, the famous "Gozo journalist" known for his bizarre behavior and interests. Shortly after his suicide in 2005, Thompson's former editorial assistant, Nickole Brown, published an article titled *In Memory of Hunter S. Thompson: Postcard from Louisville, Kentucky* where she talked about some of the strange behavior she observed while working for him. "For weeks he played a tape recording of a jack rabbit screaming in a trap," the article says. Brown also wrote that, "One time I watched him beat his car because his cigarettes were locked inside, and another time he threw me out of the house for refusing to watch a snuff film."[310]

A photographer named Rusty Nelson, [Russell E. Nelson], who is connected to the infamous Franklin Cover-Up child abuse scandal of the 1980s,[311] alleged that Hunter S. Thompson offered him $100,000 in 1988 to shoot a snuff film involving a child.[312] Rusty said he

[309] DeCamp, John - *The Franklin Cover-Up: Child abuse, Satanism, and Murder in Nebraska* page 105
[310] *PW.org (Poets & Writers)* "In Memory of Hunter S. Thompson: Postcard From Louisville, Kentucky" by Nickole Brown (posted 4.15.05)
[311] *Washington Times* "Homosexual Prostitution inquiry ensnares VIPs with Reagan, Bush" (June 29, 1989)
[312] Radio Interview - *A Closer Look* with Michael Corbin (April 12, 2005)

turned the offer down. Hunter S. Thompson's supporters insist Thompson is innocent and may have been investigating such rumors and activities for a book or featured article, and say that's how his name became connected to these conspiracies.

Lilith Fair

In 1997, several female artists got together to create Lilith Fair, an all-female music festival often called Lesbian-fest, Breast-fest, or Girlapolooza by critics who ridiculed it for its very concept. The very name for the concert series came from the Jewish legend that a woman named Lilith was actually created before Eve in Biblical times as Adam's first wife, but Lilith was said to be an evil and rebellious woman, so God later created Eve as Adam's counterpart.

In ancient Jewish and Babylonian legends, Lilith is said to be a demon, and many believe this name was chosen for the all-female festival as a way to symbolically represent their rebellion against men and the traditional gender roles that have been in place for thousands of years.

After three summers (1997 through 1999), the gang of girls abandoned their Lilith Fair concept, probably because most women didn't want to go to a concert without their boyfriend and the limited lesbian market they were appealing to couldn't financially sustain such a large event.

177

Rock and Heavy Metal

Rock and heavy metal bands have been accused of promoting Devil worship for decades, reaching a peak in the 1980s and 90s with bands like Slayer, Ozzy Osbourne and Marilyn Manson—with their outlandish antics on stage and singing songs about Satan, but this was "traditional" Satanism with pentagrams, Devil figures, and Bible bashing—quite different from invoking the Illuminati as we have seen emerge largely in rap and hip hop in recent years.

Since most people are familiar with Satanism in rock 'n' roll and heavy metal, I will only briefly touch on it in this book, highlighting some of the most blatant examples (as well as lesser known ones, but still significant instances nevertheless). I'll also cover some of the perhaps surprising examples of rock stars speaking out against the Illuminati, such as Korn's lead singer Jonathan Davis who called President Barack Obama an "Illuminati puppet," and bands like Muse, who appear to be opposed to the super class ruling elite.

Other artists such as Megadeth's front man Dave Mustaine have given interviews about the New World Order agenda, and Les Claypool of Primus even wrote a song about the infamous Bohemian Grove and the "Phantom Patriot" arrested in 2002 for breaking into their

compound armed with a rifle and shotgun, planning to expose the Illuminati's elite redwood forest retreat where the ruling class meet every July to rub elbows in an informal, all-male gathering, sometimes called "Bilderberg in the woods"—a place where the Manhattan Project (the atomic bomb) was conceived, and where Ronald Regan and Richard Nixon are said to have negotiated their political futures.[313]

Korn

PHOTO: Korn's album *The Path of Totality* includes a song titled "Illuminati."

The metal band Korn (sometimes called new metal, or neo-metal) rose to fame in the 1990s with songs like "A.D.I.D.A.S." and "Follow the Leader," thanks to their unique style of combining heavy metal, rock, and

[313] *The Washington Post* – "Bohemian Grove: Where the rich and powerful go to misbehave" by Elizabeth Flock (6-15-2011)

grunge. Lead singer Jonathan Davis has revealed the unique meaning behind some of their songs, and admitted he has studied the Illuminati and the New World Order for some time now.

In an interview with *Bilboard.com* in 2011, Davis called President Barack Obama an "Illuminati puppet," and said, "He's basically dragged this country down into the worst it's ever been. Like I say about the White House, 'You've built this house of shame.' Everybody looked up at the White House and America, and now I think it's like a house of shame. I miss the old days when people were proud to be American."[314]

The band's album *The Path of Totality* includes a song titled "Illuminati," which goes, in part:

> Parasites, they run around
> The culprits won't be found
> They lie behind this mask of wealth
> They're taking over now
> Illuminati they hide

While in Germany signing autographs at the Ramstein Air Base Jonathan Davis was approached by a fan and asked who he would prefer to take over as president out of the four Republican presidential candidates running in 2012, to which he responded, "Ron Paul." The interaction was videotaped by the fan and posted on YouTube.[315]

While it is encouraging to hear that a rock star of Korn's caliber would publically denounce Obama as an

[314] *Billboard.com* "Korn Talks 'Path of Totality': Video Track-By-Track" (December 2011)
[315] *YouTube* "Lead singer of Korn, Jonathan Davis, endorses Ron Paul" by Miles Scovern (March 17th 2012)

Illuminati puppet, Davis is far from being an angel himself. Many even accuse him of being a Satanist. He goes by the nickname JDevil, and at times appears to be obsessed with the darker aspects of life. Korn's drummer Brian Welch quit the band in 2005 after becoming a Christian and wanting to focus on raising his daughter and being a good father.[316] There is no bad blood between Welch and his former bandmates, and they all appear to still be friends.

So while Jonathan Davis may not be a poster child for a squeaky clean rock star, it is admirable that he risked isolating half his audience by denouncing President Obama, particularly with the kind of language he used, slamming him with the appropriate title of "Illuminati puppet," not to mention writing a song about how the Illuminati is bringing us all down.

[316] *MTV.com* "Brian 'Head' Welch Explains Why He Left Korn Guitarist had become sick of 'chasing the almighty buck.'" by James Montgomery (February 25th 2005)

Megadeth

PHOTO: Megadeth's album cover for *End Game*.

A surface level look at Megadeth (spelled Megadeth without the "a" if you're not familiar with the band) may lead one to believe they are a typical "satanic" heavy metal band, but upon closer inspection it becomes clear that the band's primary mission is to warn people about the elite Illuminati, the New World Order, and out of control power-mad politicians.

Songs like "Symphony of Destruction" and "Foreclosure of a Dream" paint a terrifying picture of what the superclass oligarchy has been doing to mankind. Founder and lead singer Dave Mustaine has spoken publicly about his beliefs regarding the New World Order and the End Times, and has become friends with talk show host Alex Jones from Infowars.com through a mutual admiration for each other's work.

During an interview on *The Alex Jones Show*, Mustaine spoke about the Obama administration selling

guns to the Mexican drug cartels, a scandal that came to be known as Operation Fast and Furious which was designed as a false flag attempting to convince the American people that Mexican drug lords were getting their guns from American gun shops, when in reality it was our own government providing the weapons in a top secret covert operation.[317] "Nobody can deny that there were criminal rogues within the administration and CBS News got the memos, Congress has the information and basically Larry Pratt of Gun Owners of America who is a highly respected person said that if they would stage Fast and Furious they'd be capable of staging anything and it was all done to blame the second amendment," Mustaine told the Alex Jones.[318]

The goal of Operation Fast and Furious was to justify stricter gun control laws in America by blaming our second amendment for the drug cartel violence south of the border by trying to convince the unsuspecting public that the source of the violence were American gun shops, when in reality, covert elements of our own government were the source of the weapons.[319]

Dave Mustaine had abused alcohol for years and become legendary in the music industry in the 1980s for his drunken disasters, leading to him getting kicked out of Metallica before his Megadeth days. Through his tough times and tribulations, Mustaine eventually became a born

[317] *World Net Daily* "Fast and Furious called false flag against gun dealers" by Taylor Rose (04/03/2013)
[318] *Billboard.com* "Megadeth's Dave Mustaine Doubles Down on Government Shooting Claims" by Billboard Staff (August 17, 2012)
[319] *Infowars.com* "Obama Administration Caught Running False Flag Against Second Amendment" by Paul Joseph Watson (June 24, 2011)

again Christian and began refusing to appear in concert with any bands that were overtly satanic.

Despite his surprising religious revelations, Megadeth continues to record new albums and perform to sold out shows around the world and are considered by many to be one of the greatest heavy metal bands of all time. One of their more recent songs titled "New World Order" talks about how all currency will become obsolete and that "Revelation has come to pass" and "all rights will be denied" and warns "without the mark you shall die," referring to the mark of the Beast.

> Just like the Pied Piper
> Led rats through the streets
> We dance like marionettes,
> Swaying to the Symphony...
> Swaying to the Symphony...
> Of Destruction
> -*Symphony of Destruction*

Les Claypool

The singer of the band Primus wrote a song about the Phantom Patriot, the guy who snuck into the infamous Bohemian Grove years ago armed to the teeth with the goal of exposing what he believed were human sacrifices going on there at the hands of the Illuminati.

In January 2002, a 37-year-old man named Richard McCaslin, who called himself the Phantom Patriot, snuck into the Bohemian Grove compound, located in the northern California redwood forest, while wearing a superhero outfit and bringing with him a loaded

MK-1 rifle-shotgun.[320] He had heard the allegations of human sacrifice said to occur inside, and hoped to expose this to the world.

After setting a building on fire, he was captured by police without incident and sentenced to eleven years in prison, an extended sentence because he committed a crime while wearing a bullet proof vest, which is an added charge in California.[321]

Les Claypool lives in Occidental, California, a small town right next to Bohemian Grove, and likely became familiar with the rumors and allegations surrounding this nearby retreat, and after hearing about the Phantom Patriot's attempted infiltration, Claypool was inspired to write a song about him.

> Walking through the compound
> With a formulated plan
> There to help his fellow man
> At this decisive point in time
> The Bohemians at the Grove
> Don't see it quite the same
> Smelling danger in his game
> They dub his quest a crime
> *-The Phantom Patriot*

[320] *San Francisco Chronicle* "Bohemian Grove commando found guilty" by Kelly St. John (April 17, 2002)
[321] Ibid

Don Henley

PHOTO: Album cover for Don Henley's single "Inside Job."

Singer Don Henley from the legendary rock group The Eagles released a solo album in the year 2000 titled "Inside Job" that included a song with the same title which lamented about government corruption and "inside jobs." Even though the song was recorded and released before the September 11th terrorist attacks, which many people believe were an "inside job" and a false flag attack orchestrated by the Illuminati, the song became almost an anthem for the 9/11 truth movement.

"It was an inside job by the well-connected," Henley sings, and "they know what you've had for breakfast and what you've hid beneath the mattress." The song is a powerful critique of corruption in government, which Henley says is "business as usual."

While Don Henley hasn't made any public statements about the 9/11 attacks being an inside job, he has been critical of the War on Terror, saying "We think we're civilized because we can put a man on the moon and

cure some types of cancer, but we are just as primitive and backward as we ever were."[322]

"I didn't like him [Bush] when he was governor, and I don't like him now. I support the troops, but I don't support the people who sent them there [to Iraq] because it wasn't necessary."[323]

Don Henley's 1982 song "Dirty Laundry" is about the news business and how people love the thrill of watching stories about tragedies told to them by beautiful talking heads reading from a teleprompter—and even though the song is over thirty-years-old, it still rings true today.

> We got the bubble-headed-bleach-blonde
> Who comes on at five
> She can tell you about the plane crash
> With a gleam in her eye
> It's interesting when people die-
> Give us dirty laundry
> *-Dirty Laundry*

[322] *The Telegraph* "The Eagles: we're lucky to be alive" by Neil McCormick (November 1st 2007)
[323] *Scoop* "Don Henley Slams Bush & Iraq War In Thailand" by Richard S. Ehrlich (October 14, 2004)

Ministry

PHOTO: Album cover for Ministry's *Rio Grande Blood.*

The cover art on Ministry's *Rio Grande Blood* album depicts President George W. Bush standing in a barrel of oil while making "hail Satan" el Diablo hand signs with an Illuminati All-Seeing Eye on his forehead and fighter jets and oil fields in the background. The album, released in 2006, contains several tracks denouncing the War on Terrorism and even included some references to 9/11 being an inside job.

One of the songs, "Lies Lies Lies," sampled sound bites from the narrator of the popular Internet film *Loose Change*, using statements like, "Do you still think that jet fuel brought down the World Trade Center?" referring to the controlled demolition hypothesis found in many 9/11 truth circles.

Muse

PHOTO: Album cover for Muse's *The Resistance*.

 The British rock band Muse achieved international success, particularly in America, with their 2009 album *The Resistance*, and their hit single "Uprising" which sounded like a battle cry against a tyrannical and out of control government. The band's singer Matt Bellamy even publicly stated that he believed 9/11 was an inside job and sometimes wore a t-shirt on stage reading "Terrorstorm," the name of Alex Jones' popular 2006 film which covers the history of false flag attacks and government staged events that have been fabricated as pretexts for military action and war.

 In a 2006 interview, Bellamy said, "There was a document called 'Project For The New America Century'... which clearly says, 'We need a Pearl Harbor-level event so we can have an excuse to invade the Middle East,'" and elaborated on his suspicions 9/11 was a false flag attack orchestrated or allowed to happen by corrupt elements within the United States government.[324]

[324] *CMU Daily* "On the Inside" (October 13th 2006)

While many truth seekers and "Resistance" supporters thought they found a friend with the band Muse, after achieving international success, their tune would strangely change and Matt Bellamy began backpedaling on his previous controversial statements. It began with him expressing disappointment that many Tea Party supporters had adopted the song "Uprising" to represent their political frustrations with big government and the Obama administration. When asked about radio host Glenn Beck playing his song at a Tea Party event, Bellamy answered, "I suppose it's nice that he's a fan of the music, but I don't want people to start using our music for strange, obscure political movements."[325]

He didn't even know who Glenn Beck was and called the Tea Party "bizarre."[326] What's bizarre is the fact that the band was upset that their song was adopted by people who felt its message illustrated their frustration with the government, and it's especially bizarre considering that's the point of the song.

Bellamy would later retract his statements about the September 11th attacks being an inside job, and said his views had become "more nuanced now" and that "I don't believe that any more." [327] Bellamy bred with Hollywood royalty when he had a son in 2010 with actress Kate Hudson, daughter of Goldie Hawn, and many accuse him of changing his stance on 9/11 and the "Resistance" so he wouldn't be ostracized by the Hollywood crowd, or to prevent certain doors from being closed which would

[325] *Kroq* "Muse's Matt Bellamy: 'I Don't Want People Using Our Music For Strange, Obscure Political Movements'" (January 30, 2013)
[326] Ibid
[327] *NME* "Muse's Matt Bellamy says he no longer thinks 9/11 was an 'inside job'" (September 24, 2012)

have prevented him from producing another hit album because of these views.

What's also interesting is that in 2008, the year before Muse achieved international success with their album *The Resistance*, they recorded a live album titled *HAARP*, named after the mysterious High Frequency Active Auroral Research Program in Gakona, Alaska that is believed by many to be a weather weapon or massive mind control device.[328] When asked about the album title Bellamy stated, "Some people think it's designed to tap into the ionosphere to control the weather. Others think it's there to diffuse UFO beams, or to send out microwaves to control our thoughts."[329] During the band's performances they would even bring out large antennas and satellite dishes on stage as props to make it look like the HAARP facility.[330]

As can be expected, Matt Bellamy seems to have changed his tune on HAARP as well after achieving mainstream success in America. Perhaps his handlers made it clear to him what the music monopoly corporations want from their stars if they're going to pull the strings needed to be a part of the "in crowd" in the industry.

> Rise up and take the power back
> It's time the, fat cats had a heart attack
> You know that, their time's coming to an end
> We have to, unify and watch our flag ascend
> *-Uprising*

[328] The government claims the facility has been shut down as of 2013, and has always denied it was a weapon of any kind.
[329] *Q* "Best Live Act" (October 6th 2009)
[330] *Virgin Radio* "Most Wanted with Ben Jones" (February 2nd 2008)

Fatboy Slim

PHOTO: Album cover for Fatboy Slim's "Illuminati."

The British DJ, Fatboy Slim, produced a song titled "Illuminati" for Angelina Jolie's film *Lara Croft: Tomb Raider,* in which Jolie's character Lara Croft is being hunted by the Illuminati as they search for a mystical pyramid-shaped artifact that will give whoever possesses it unimaginable power over space and time. In the film, Jolie is working to discover the artifact before the Illuminati in order to prevent them from obtaining it.

Fatboy Slim's song is basically an instrumental for the film's soundtrack and just repeats the same few words at various times throughout the song. "Illuminati. A secret society do exist." Note: The lyrics actually say, "a secret society *do* exist," not "does exist," which is the proper grammar, and was apparently an attempt at some kind of artistic expression for the track.

System of a Down

When a cameraman from TMZ bumped into Serj Tankian, lead vocalist from System of a Down, he asked him a very unusual question. Keep in mind, TMZ cameramen are just hired paparazzi, not trained journalists who know how to conduct an interview. If you've ever seen any TMZ interviews, they usually consist of the cameraman asking the stars their opinion about the latest celebrity scandal or their current project, but this time the cameraman asked an interesting question about the Illuminati in the music industry—a topic you know by now was getting fairly popular.

Even though the paparazzi asked a pretty good question concerning the numerous allegations and conspiracy theories on the Internet about this, instead of showing Serj Tankian's answer, the video cuts away to a guy doing a voice over who says, "I'll take this one," and then some creepy music kicks in and the announcer tells a minute long story about the Illuminati in a very sarcastic and tongue-in-cheek kind of way and never actually shows what Tankian's response was.

What else can be expected from TMZ and the editor-in-chief Harvey Levin, the orally fixated celebrity suck up? While giving a speech at his alma mater the University of Chicago Law School in 2010, Harvey revealed he once had the idea for TMZ DC where he wanted to deploy paparazzi in Washington DC to interview politicians and he "almost did it," but due to what he called "some circumstances" he was prevented

194

from doing so.[331] TMZDC.com is actually a registered domain name but leads to a page saying it's unavailable and shows it's owned by Warner Brothers.

Pink Floyd

PHOTO: Cover for Pink Floyd's *Dark Side of the Moon.*

The Dark Side of the Moon is one of the bestselling albums of all time, released in 1973 and still resonating with people today, but because the album cover features a pyramid with a beam of light shining through it, Pink Floyd is sometimes accused of "being Illuminati" too. People who slap the "Illuminati" label on Pink Floyd clearly reveal their ignorance (or their paranoia) because sometimes a triangle is just a triangle.

[331] *YouTube.com/UChicago* "Harvey Levin Talks about Privacy and the Media with University of Chicago Law Students" [0:36:42] (October 21st 2010)

All of the artists mentioned in this book who use triangles, pyramids, and other Illuminati affiliated symbols, do so with the intention of portraying themselves as being "in the know" or "insiders" privy to the Illuminati's power, and the content of their music (as well as their character) is clearly dark and devilish; but in the case of Pink Floyd, their use of a prism with a beam of light shining through it was simply an interesting artistic expression that some people have read *way* too much into.

In fact, anyone who is familiar with Pink Floyd's *Dark Side of the Moon* or *The Wall*, most likely understands and appreciates the band's skillful articulation of the mysteries and the struggles of life, love, money, and happiness; and relates to the singer's search for answers in this reality we are all experiencing. Their music is far from sinister, and is instead—inspiring, thought provoking, and quite profound.

For example, the song "Money" is a popular tongue-in-cheek track mocking greed and mindless consumption, while "Time" serves as a warning for people to pay attention to their life and priorities, urging them to examine what they do with their time so they don't end up wasting their life before it's too late. The final track on *The Dark Side of the Moon*, titled "Eclipse," serves as an introspection on one's entire life, helping the listener evaluate their past actions and what their life has meant as a result of them.

> And then the one day you find
> Ten years have got behind you
> No one told you when to run
> You missed the starting gun
> *-Time*

Bono

PHOTO: Bono in a Water.org advertisement joking about being at an Illuminati meeting.

One might not expect to find *U2* front man Bono in the crosshairs of Illuminati allegations, but he brought it upon himself when he appeared in an ad for Matt Damon's Water.org charity, an organization working to bring water filtration systems to third world countries so they can have safe drinking water. In the ad when Bono is explaining the charity's mission, he said the Illuminati had come up with the plan!

"I remember when Matt first brought up the idea, it was at a meeting of the Illuminati," Bono said, trying to be funny since celebrity Illuminati allegations had become fairly well known by this time. Actress Olivia Wilde and billionaire Richard Branson also appeared in the ad and continued to crack jokes about their "secret Illuminati meeting" where Matt Damon was said to have hatched his plan to help the poor. The online backlash was apparent in the comments and the user ratings of the video, which ended up getting a two-thirds thumbed down rating and

the anti-Illuminati comments just kept pouring in, one right after the other. Their attempt at Illuminati humor had failed miserably.

While the Water.org skit can simply be written off as a bad joke that backfired, a closer look into Bono's messages reveal his seeming adoration for the Devil, stemming in part by him covering the Rolling Stones' "Symphony for the Devil" during his performances, which is a song dedicated to Satan.

In the 1980s while doing a cover of the Beatles' song "Helter Skelter," Bono would wear a necklace with an upside down cross on it. *Helter Skelter* was Charles Manson's theme song, by the way, and was the term he used to describe his cult's murderous rampage. In U2's song "In God's Country," Bono declares that "I stand with the sons of Cain,"[332] the man who in Biblical times murdered his innocent brother Abel, and has become synonymous with an evil murderer ever since.

During his Zoo TV tour back in the early 1990s, Bono would appear on stage wearing Devil horns when portraying his alter ego "MacPhisto," an English Devil character he devised for part of the show.[333]

[332] Songfacts.com
[333] *Los Angeles Times* "Building the Beast" by Robert Hilburn (April 20, 1997)

Marilyn Manson

PHOTO: Marilyn Manson in "Dope Show," dressed as his usual freakish self, this time with prosthetic breasts.

While his fifteen minutes of fame faded away in the late 1990s, Marilyn Manson made quite an impact on his impressionable fans, encouraging their idiocy every chance he got. This creepy creature was not just portraying a character who was sick and twisted, but instead was living out his own dark fantasies while using his stage name, an amalgamation of Marilyn Monroe and Charles Manson. When one looks into the personal life of Brian Warner (his real name) it becomes clear that he is a mentally deranged demon who made millions peddling his psychosis to his psychologically sedated fans.

During the height of his fame in the late 1990s, while on stage at the *MTV Music Awards*, Manson proclaimed, "My fellow Americans—We will no longer be oppressed by the fascism of Christianity! And we will no longer be oppressed by the fascism of beauty. As I see you all sittin' out there trying your hardest not to be ugly, trying your hardest not to fit in, trying your hardest to earn

your way into Heaven, but let me ask you—Do you want to be in a place that's filled with a bunch of assholes?"[334] A standard part of his performances was tearing pages out of a Bible and tossing them into the air.

Manson's bizarre behavior is not just an on stage act though. He reportedly wanted to keep his girlfriend's aborted fetus after she had an abortion,[335] and a lawsuit filed by a former band member, Stephen Bier, alleged that Manson had purchased a skeleton of a 4-year-old child from China, masks made out of human skin from Africa, and collected Nazi memorabilia, including Adolf Hitler's coat hangers.[336]

The Columbine school shooting was one of the most infamous instances of school violence where Eric Harris and Dylan Klebold assaulted their Colorado high school in 1999, killing twelve students and one teacher, marking the beginning of a new trend of mass murder now commonly known as "school shootings." The two killers were said to be big fans of Marilyn Manson, and many people pointed to Manson's music as a possible inspiration for the killing spree.[337] What the mainstream media didn't really report on was the fact that the two killers were specifically targeting Christians in their killing spree, and witnesses reported that while pointing a gun at 17-year-old Cassie Bernall's head, one of the

[334] 1997 MTV Music Awards
[335] *MTV.com* "Marilyn Manson Sued: Keyboardist Claims Rocker Spent Band Money On Drugs, Nazi Artifacts" by Chris Harris (August 2, 2007)
[336] *Side Line Magazine* "Marilyn Manson is a fraudulous nazi artifacts collector says former bandmember" (6/08/07)
[337] *VH1* "Marilyn Manson Blamed For Columbine Shootings" by Kate Spencer (August 8th 2008)

psychos asked, "Do you believe in God?" When she answered "yes," he shot her.[338]

While Manson denied his music and antics had any influence on the boys, he has stated that, "Music is the strongest form of magic," and he no doubt revels in being a high priest from Hell. It's amazing how musicians can deny their music has any negative consequences on certain members of their audience, while at the same time admitting their music is magical and holds a mysterious power over people. Did I mention Marylyn Manson is a card carrying member of the Church of Satan? He is. That's no joke.[339]

[338] *World Net Daily* "'Do you believe in God?'" (04/26/1999)
[339] *Wikinews* "Interview with Church of Satan high priest Peter H. Gilmore" (November 5th 2007)

Ozzy Osbourne

Very briefly I'll touch on Ozzy Osbourne, one of the most popular rockers from the 1980s and 90s who has a satanic cloud hanging over his head because of his music and on stage antics which have resulted in several lawsuits by parents who accused Ozzy of encouraging their children to commit suicide.[340]

Ozzy is best known for biting the head off a dove during a meeting with executives at CBS Records in Los Angeles in his early days. He literally brought a live dove to the meeting and bit its head off and spit it out onto the table during the meeting.[341] The record executives probably loved the stunt and realized what a satanic shock rocker they had in front of them, and the stunt likely excited them about signing him even more.

Then, there was the time he bit the head off a bat while on stage during one of his performances and reportedly had to get a rabies shot because the bat bit his tongue during the incident.[342] These "head-biting" incidents were largely what "made" Ozzy, and have become legendary in the music business.

In 1985, a teenager named John McCollum committed suicide after allegedly listening to Ozzy's song "Suicide Solution," and the boy's parents then sued Ozzy claiming the song inspired the boy to kill himself with lyrics like, "Where to hide, suicide is the only way out.

[340] McCollum v. CBS and Waller v. Osbourne
[341] *100.7 WZLX Classic Rock* "Ozzy Osbourne: 12 Crazy True Rock Star Stories"
[342] *The Guardian* "Lord of the wings" Observer Music Monthly by Barbara Ellen (May 19, 2007)

Don't you know what it's really about?" The lawsuit was eventually dismissed.[343]

Years later in 1991, another family sued Ozzy claiming his songs also inspired their son to kill himself.[344] This case was also dismissed. Ozzy, who is often called "the Prince of Darkness," once made reference to the infamous Satanist Aleister Crowley in a song named after him. Many people unfamiliar with the activities and writings of Crowley have no idea what the song "Mr. Crowley" is actually about. Crowley, as you should know by now from reading this book, was an infamous Satanist in the 20th century who wrote instructions for satanic rituals that include animal and human sacrifice,[345] and he is a hero for many musicians still to this day.

From 2002 to 2005 Ozzy was the star of MTV's most watched show at the time, titled *The Osbournes,* which followed his dysfunctional family's activities. He later admitted he was stoned during the entire show, which should come as no surprise if you've ever heard him speak.[346] What most of the audience didn't know, however, is that one of Sharon and Ozzy's daughters refused to participate in the show and producers had to blur her out of any family photos they showed on TV.[347]

[343] Listed at FindLaw.com: 202 Cal.App.3d 989, McCollum v. CBS, Inc., 12 July 1988. No. B025565
[344] Waller v. Osbourne
[345] Crowley, Aleister – Magick: In Theory and Practice p.95-96
[346] *Daily Record* "I was stoned every day while filming The Osbournes, admits Ozzy Osbourne" by Rick Fulton (May 4 2009)
[347] *Daily Mail* "Sharon Osbourne bonds with her rarely seen daughter Aimee on Hawaii beach" (June 30, 2011)

Since she wouldn't sign a release, for the sake of the show, it was as if she simply didn't exist.[348] In the show's heyday, Ozzy was invited to the White House Correspondence Dinner as a special guest of Fox News' Van Susteren (a reported Scientologist),[349] and George W. Bush even gave him a shout out from the podium during his speech, giving the rock and roll role model the presidential stamp of approval. More recently Peter Joseph, the producer of the Communist propaganda and anti-Christian *Zeitgeist* film series, directed the music video for Ozzy's "God is Dead?" a dark and depressing song that serves to erode people's faith in God, leaving them without a spiritual or moral compass.

> Mr. Crowley, what went on in your head
> Mr. Crowley, did you talk with the dead
> Your life style to me seemed so tragic
> With the thrill of it all
> You fooled all the people with magic
> You waited on Satan's call
> -*Mr. Crowley*

[348] Ibid
[349] *St. Petersburg Times* "High profile couple never pairs church and state" by Mary Jacoby (December 13, 1998)

AC/DC

PHOTO: AC/DC's album cover *Highway To Hell.*

Considered one of the greatest artists of all time by VH1 and *Rolling Stone* magazine, AC/DC is a rock band that has spanned decades with hits like "Highway to Hell" and "Dirty Deeds Done Dirt Cheap"; songs that still get radio play today. Even though the band is basically a thing of the past, many music buffs are likely to be familiar with them, but what most people don't know about AC/DC is the band's connection to the notorious serial killer Richard Ramirez, who was nicknamed the "Night Stalker."

This is the infamous California serial killer who drew a satanic pentagram on the palm of his hand and proudly showed it off in the courtroom during his trail. He also frequently shouted "Hail Satan." Ramirez killed at least thirteen people in Los Angeles between 1984 and 1985, and some say his killing spree was inspired by an AC/DC song titled "Night Prowler," where the lyrics

appear to speak of a psycho running around at night killing people.

Police reported Richard Ramirez wore an AC/DC t-shirt during his murder spree and even left an AC/DC hat at the scene of one of his crimes.[350] The Night Stalker was also a fan of Anton LaVey, the founder of the Church of Satan, and had read his *Satanic Bible*, first published in 1969. It was Anton LaVey who coined the phrase "Hail Satan," the mantra of Ramirez.

In his authorized biography titled *The Secret Life of a Satanist*, LaVey admitted that he wasn't concerned if Satanism allegedly inspired people to commit mass murder. It reads, "Anton LaVey maintains that he isn't really concerned about accusations of people killing other people in the name of Satan. He swears that each time he reads of a new killing spree, his only reaction is, 'What, 22 people? Is that all?'"[351] This authorized biography goes on to read, "There will undoubtedly be more Satanically-motivated murders and crimes in the sense that *The Satanic Bible* tells you 'You don't have to take any more shit.'"[352]

Also in the authorized biography (authorized, meaning it was approved by his estate, and written by his widow Blanch Barton) LaVey is reported to have admired a serial killer from the early 1900s named Carl Panzram, a monster who killed twenty-two people, and who claimed to have raped one thousand men. "The only way I would like to 'help' the great majority of people is the same way

[350] March 17, 1985- at the murder scene of victim Dayle Okazaki
[351] Barton, Blanche – *The Authorized Biography of Anton LaVey* page 218
[352] Barton, Blanche - *The Authorized Biography of Anton LaVey* page 219

Carl Panzram 'reformed' people who tried to reform him. It would be most merciful to help them by relieving them of the life they seem to hate so much. People should be happy I'm not a humanitarian—or I'd probably be the most diabolical mass murderer the world has ever known," LaVey is quoted as saying[353]

In the 1980s, AC/DC's concerts and albums were faced with protests and they received a lot of bad publicity because of their alleged connection to the Night Stalker serial killer. The band has always denied their music had any influence on Ramirez.

> I'm your night prowler, asleep in the day
> Yes I'm your night prowler, get outta my way
> Look out for the night prowler, watch out tonight
> Yes I'm your night prowler, when you turn out the light
> I'm your night prowler, break down your door
> I'm your night prowler, crawling across your floor
> I'm the night prowler, make a mess of you, yes I will
> *-Night Prowler*

[353] Barton, Blanche – *The Authorized Biography of Anton LaVey* page 133

Insane Clown Posse

PHOTO: Album cover for Insane Clown Posse's
The Great Milenko.

The Detroit shock rock/gangster rap group Insane
Clown Posse, who always appear on stage in clown
makeup, are known not only for their violent and twisted
lyrics, but also for their cult-like following of deranged
and dedicated fans. The group's style is called horror
core, because of the horror themes found in most of their
songs. ICP fans, called Juggalos, often attend concerts
with their faces pained up like the group's frontmen
Violent J and Shaggy 2 Dope, and have gained a
reputation, as *Spin Magazine* points out, for their
"obscenity" and their "stupidity."[354]
 Of course violent and reckless people are attracted
to violent music, but ICP fans seem to be in a league of
their own, and the Juggalos were labeled a gang in 2011

[354] *Spin Magazine* (January 1998 issue)

by the FBI in their *National Gang Threat Assessment (NGTA)* report, which states, "The Juggalos, a loosely-organized hybrid gang, are rapidly expanding into many US communities. Although recognized as a gang in only four states, many Juggalos subsets exhibit gang-like behavior and engage in criminal activity and violence. Law enforcement officials in at least 21 states have identified criminal Juggalo subsets, according to NGIC [National Gang Intelligence Center] reporting."[355]

It went on to read, "Most crimes committed by Juggalos are sporadic, disorganized, individualistic, and often involve simple assault, personal drug use and possession, petty theft, and vandalism. However, open source reporting suggests that a small number of Juggalos are forming more organized subsets and engaging in more gang-like criminal activity, such as felony assaults, thefts, robberies, and drug sales. Social networking websites are a popular conveyance for Juggalo sub-culture to communicate and expand."[356]

In 2013 the clowns (no pun intended) in ICP jumped on the secret society fad, shooting a video for their song "Forever" inside a Masonic temple. In a brief behind the scenes sneak peak, Violent J starts by saying, "Here's what's real special. We're at the ultra-mysterious Masonic temple." Shaggy 2 Dope, the other dope in this deranged duo, then says, "Just from what I've seen, there's sacrificial rooms up in this piece, mad catacombs in the basement..." Violent J's older brother, named "Jumpsteady," pipes in saying, "I don't

[355] FBI 2011 *National Gang Threat Assessment – Emerging Trends* page 22
[356] FBI 2011 *National Gang Threat Assessment – Emerging Trends* page 22-23

even want to tell you about the Chamber of Reflections, that's an ultra-secret..." to which Violent J cuts him off pretending he wasn't supposed to mention it, saying, "Why did you just put that on tape, you're going to get us killed."[357]

Since the Freemasons and Illuminati have become a part of pop culture and known for their alleged dark power, ICP figured they too would throw their hat in the ring (albeit a bit late compared to most other musicians), and claim some connection to the esoteric fraternity to further their "evil" personas. In reality, ICP are just opportunistic rapping shock jocks in face paint performing horror core music, mainly to an audience of misguided teenagers who are rebelling against their parents and society in the most juvenile ways imaginable.

I'm hating sluts
Shoot them in the face, step back and itch my nuts
Unless I'm in the sack
Cuz I fuck so hard it'll break their back
-Psychopathic

Woodstock 99

In 1999, concert promoters brought back the Woodstock music festival trying to emulate the famous event from the summer of '69, only this time the festival was cut short because of violence, rapes, and fires started by an out of control audience.[358] The chaos began after

[357] Interview on ICP's App about "Forever" Music Video
[358] *Washington Post* "Woodstock '99 Goes Up in Smoke" by Alona Wartofsky (July 27, 1999)

Limp Bizkit front man Fred Durst took the stage to perform their hit "Break Stuff" and announced to the crowd, "It's time to reach down deep inside and take all that negative energy and let that shit out of your fucking system."[359]

Almost immediately, the crowd began dismantling vendors' booths, setting fires, and virtually rioting, sending dozens of people to the hospital. 500 police officers were sent in wearing riot gear to calm the raging crowd and shut the festival down. Of course, it's no coincidence that the song "Break Stuff" is about going on a reckless rampage, as the title suggests, and with the added encouragement of Fred Durst telling the audience to "reach down deep inside and take all that negative energy and let that shit out of your fucking system," they took that as a cue to literally "break stuff," shutting down the festival and making it an embarrassment for the other musicians who participated in the event.

Despite the tough "bad boy" image he portrayed on stage and in his music, Durst once admitted, "I play the pimp thing on purpose. Like when I'm on MTV, these chicks are fanning and massaging me. It's not like I attracted them off the street, we fucking hired 'em! I want everyone to be thinking I'm having the time of my life, but I'm single and miserable."[360]

Limp Bizkit is now a thing of the past, and basically just a footnote in music history. Durst admitted to *Entertainment Weekly* that, "In 2000, there were 35 million people who connected to this band. Twelve years

[359] Live From Woodstock '99 – Limp Bizkit
[360] *Entertainment Weekly* "Right Said Fred" by Gary Susman (February 13, 2002)

later, lots of those people have moved on. We were a moment in time and it's over."[361]

Apparently, most of Limp Bizkit's high school and college-aged fans grew up and left behind this two hit wonder, whose songs "Break Stuff" and "Nookie" played in the background at one too many keg parties. When Fred Durst's money comes close to running out it will be interesting to see if he tries to make a comeback with a makeover, marketing himself as the "softer" more "sensitive" rocker who has turned away from his angry and rebellious past.

The Woodstock '99 disaster is the perfect example of how people will mindlessly obey the messages of the music they're listening to, without thinking, or even caring what the consequences are. It also shows how large audiences engage in Group Think, and like mindless sheep will follow the herd through the gates of destruction guided by a man with a microphone singing commands they obey without question.

I pack a chainsaw
I'll skin your ass raw
And if my day keeps going this way, I just might
Break your fucking face tonight
-*Break Stuff*

[361] *Entertainment Weekly* "Fred Durst says the reason Limp Bizkit isn't around is because you don't love Limp Bizkit enough" by Kyle Anderson (Aug 17, 2012)

Country Music

Country music is practically void of Illuminati symbolism and satanic messages because unlike rock and roll, heavy metal and hip hop, the country music genre is very different in that as a whole it doesn't promote rebellion or flaunting one's wealth or try to push the envelope like other genres of music do. That's not to say there aren't Illuminati allegations surrounding some famous country music stars, but largely the Illuminati allegations are centered around rap, hip hop, rock, and heavy metal.

When country music stars sing about drinking, they're usually singing about drowning their sorrows over a broken heart, not popping Cristal in the club because they're living like there's no tomorrow. When they sing about fighting it's usually a justified punch in the face to some scumbag harassing a nice girl at the bar. The only time guns are really mentioned in country songs is when the artists are talking about having a shotgun in the back of their pickup truck or on the farm to protect their families like good old boys in the country do. They're not singing about killing people for a power trip like we've heard so many rappers do.

Perhaps the most violent messages in country music were when Carrie Underwood sung about keying

213

the paintjob and slicing the seats of her cheating boyfriend's truck in "Before He Cheats" or when the Dixie Chicks sung about killing "Earl," a wife-beating husband in a song about domestic abuse.[362]

Yes, there was the odd alternative rock alter ego of Garth Brooks he named "Chris Gaines," and Johnny Cash sung "I shot a man in Reno," but these few and far between examples of questionable messages in county music pale in comparison to the overwhelming and obvious degenerate and demonic themes that have infected the music industry.

The reason for country music's overall innocence is quite simple: Country music is designed to be a reflection of country living. The artists sing songs about the simple life and small towns—they tell tales of love and loss, of broken hearts and hard work. People who live in the country generally experience way less crime than those in the city, and they know their neighbors and look out to protect their communities in order to keep them safe and family friendly. Country folks smile and say hi to strangers, and offer others a helping hand, where city folks are often afraid to even make eye contact with people they pass on the street.

You may not like the twang of country music or think it's just a bunch of cowboy hat wearing hicks living in the sticks, but you have to admit that at least country music is practically Illuminati free, and that is the key.

[362] The Dixie Chicks – "Goodbye Earl"

Conclusion

Comedian Chris Rock once said, "There's like a civil war going on with black people, and there's two sides. There's black people, and there's niggas—and niggas have got to go! I love black people, but I hate niggas, boy! Oh, I hate niggas. Boy, I wish they'd let me join the Ku Klux Klan. I'd do a drive-by from here to Brooklyn."[363] He was obviously talking about the kinds of rappers covered in this book—the kind of people who perpetuate the worst stereotypes about black people, and those who get rich by promoting such stereotypes to their fans.

Artists like Bob Marley, KRS-One, Chuck D, Kelly Clarkston, Carrie Underwood, Jessica Simpson, and others give hope and provide good examples of musicians who can achieve tremendous success without "selling their soul to Satan." Even though pop culture is awash with satanic slime, you can choose what to feed your mind. Don't download the music of the Illuminati posers, don't include these artists on your playlists, and be sure to consciously pay attention to the content of the music you're listening to on a regular basis and turn off the trash as soon as you hear it so it doesn't sink into your mind. Realize how enormous multibillion dollar corporations do anything to milk money out of you, and they are promoting Illuminati idols to children who teach

[363] *HBO* "Chris Rock: Bring the Pain" (1996)

them to be as disrespectful, sexually promiscuous, and as spiritually bankrupt as possible.

Perhaps try listening to classical music or instrumentals and music without lyrics or words that guide your mind so it can operate freely, allowing you to listen to your subconscious or inner voice. Famed media analyst and author of *Amusing Ourselves to Death*, Neil Postman, explains most people, "are not prepared to feel or even experience the music of Haydn, Bach, or Mozart; that is to say, their hearts are closed, or partially closed, to the canon of Western music...There is in short something missing in the aesthetic experience of our young."[364]

Music is, after all, information, and the control of information is a primary key to the Illuminati's power. Let's not forget that over two hundred years ago, Illuminati founder Adam Weishaupt wrote about taking over the schools and the newspapers in order to influence society and shape people's behavior. "We must win the common people in every corner. This will be obtained chiefly by means of the schools," he explained.[365] Only a fool or a liar would, at this point, say that music doesn't influence the listeners' thought patterns, emotions and behavior—and as is the case with most mainstream music, that influence is far from enlightening.

For those who still doubt that the media can, and does, encourage the audience to mimic what they see and hear, I'll refer you to the bobo doll experiment that studied children's behavior and aggression as a result of witnessing an adult punching a bobo doll (an inflatable doll with a weight at its base that returns to its upright position after it is punched or kicked). The experiments

[364] Postman, Neil, – *The End of Education*
[365] Robison, John – *Proofs of a Conspiracy* p. 111

simply demonstrated that after children witnessed someone punching the bobo doll, they themselves were inclined to imitate that same behavior, where before they had seen someone hit the doll, the children largely ignored it. The experiment demonstrated various aspects of social learning theory and observational learning, clearly showing that the children imitated behavior they witnessed by hitting the doll themselves—or as my grandpa used to say—monkey see, monkey do.

A Senate Committee in 1999 investigated violence and its influence on children, and concluded, "Far too many of our children are killing and harming others. This report identifies and begins to redress one of the principal causes of youth violence: media violence."[366] This is 180 degrees opposed to what Michael Greene said while he was president of the National Academy of Recording Arts and Sciences at the 2000 Grammys as he tried to calm the controversy surrounding Eminem's nomination for Best Rap Album when he told the audience, "The arts solve teen violence, they are never the cause."

James Fox, Dean of the Criminology Department at Northwestern University in Chicago stated, "Murder is just not the taboo that it once was. A lot of that is television. Now, kids have become desensitized. They'll rent movies and play their favorite scenes-often the most violent-over and over. What do you think the effect is on

[366] CHILDREN, VIOLENCE, AND THE MEDIA: A Report for Parents and Policy Makers Senate Committee on the Judiciary, Senator Orrin G. Hatch, Utah, Chairman, Committee on the Judiciary, Prepared by Majority Staff Senate Committee on the Judiciary September 14, 1999

a kid when his first exposure to sex is a brutal rape scene?"[367]

In *Nineteen Eighty-Four*, George Orwell wrote about how the culture had become so rotten that, "Nearly all children nowadays were horrible...they adored the Party and everything connected with it. The songs, the processions, the banners, the hiking, the drilling with dummy rifles, the yelling of slogans, the worship of Big Brother—it was all a sort of glorious game to them."[368]

Church of Satan founder, Anton LaVey, admitted, "The TV set, or satanic family altar, has grown more elaborate since the early 50's, from the tiny fuzzy screen to huge entertainment centers covering entire walls with several TV monitors. What started as an innocent respite from everyday life has become in itself a replacement for real life for millions, a major religion of the masses."[369]

Many Christians point to the Bible to explain our backwards society, in particular, *2nd Timothy*, where it reads, "There will be terrible times in the last days. People will be lovers of themselves, lovers of money, boastful, proud, abusive, disobedient to their parents, ungrateful, unholy, without love, unforgiving, slanderous, without self-control, brutal, not lovers of the good, treacherous, rash, conceited, lovers of pleasure rather than lovers of God."[370]

As you arrive at the end of this book, I hope it has given you the evidence and facts to help you realize just how powerful music can be, and the disastrous consequences that can occur when this power is placed

[367] *USA Today* (April 11, 1995)
[368] Orwell, George – *Nineteen Eighty-Four* page 21
[369] LaVey, Anton – *The Devil's Notebook* page 86
[370] 2 Timothy 3:1-4

into the wrong hands. We must not sit by silent as these demonic false idols and Illuminati puppets have their messages shouted from speakers around the world and injected into millions of minds through headphones and ear buds. We must publically shame them and shame any TV shows or radio stations that support them.

Get positive role models in your life or in your children's lives who have set an example of how big dreams may come true through hard work and dedication without the need to compromise one's morals and integrity. Put your energy into something productive and positive, whether it's sports or other hobbies like singing, rapping, writing computer programs, painting, fixing cars, or simply being a good mom or a dad for your kids and making sure they get the best wisdom, guidance, and opportunities in life so they won't make some of the same mistakes that perhaps you have made when you were younger. Family should always come first and we must also defend the Constitution and our Civil Liberties since they are under a constant threat from a tyrannical power hungry, Illuminati controlled government that works hand in hand with the mainstream media monopoly machine to manage the masses.

Idle hands are the Devil's workshop, and energy focused in the wrong direction, or not focused at all, often brings disaster and disappointment. You could be the best at doing beer bongs, or the best track star; you could have a great girlfriend or boyfriend with a fulfilling, quality relationship, or you could get a sexually transmitted disease or an unplanned pregnancy if you are sexually irresponsible—it all depends on where you place your priorities. Pay attention to where and how you spend your money. Often we vote with our wallet, and "the system" uses every dirty trick in the book to try to get

you to spend money you don't have on things you don't need while trying to impress people you don't know. While most Illuminati icons promote a hedonistic "if it feels good, do it" YOLO (you only live once) "Do what thou wilt" live for the moment philosophy, there is an interesting paradox called the hedonism paradox or the pleasure paradox that says people fail to experience pleasure if we seek out pleasure for its own sake.[371] William Bennett, former United States Secretary of Education explained it like this, "Happiness is like a cat, if you try to coax it or call it, it will avoid you; it will never come. But if you pay no attention to it and go about your business, you'll find it rubbing against your legs and jumping into your lap."[372]

Viktor Frankl echoed this in *Man's Search for Meaning*, when he said, "Happiness cannot be pursued; it must ensue, and it only does so as the unintended side effect of one's personal dedication to a cause greater than oneself or as the by-product of one's surrender to a person other than oneself."[373]

Don't give musicians, actors, or other entertainers too much credit when they occasionally do talk about the Illuminati or the way (they think) the government or the world works. People frequently put celebrities on pedestals and give them way more credit than they deserve, and perceive them as being experts in anything they talk about. The halo effect or halo error, describes how people tend to have a bias view of others because their perception and judgment is strongly influenced by

[371] *Sophist Society* "Paradox of Hedonism" (May 4th 2011)
[372] BrainyQuote.com
[373] Frankl, Victor – *Man's Search For Meaning:* Author's Preface to the 1984 Edition page 12

one's overall impression of the person, thus distorting their assessment of that person's knowledge, skills, or importance.[374]

When people hold celebrities in high regard because they like their movies or music, most people become victims of the halo effect and think that celebrities' opinions or statements are more valuable than others, even when most of the time they have no more knowledge about the particular subject than the average person.

In closing, habitually guard your ears and mind, and be careful what you put into your brain. Just like if you eat bad food, you can get physically ill—if you listen to bad music, the same may be true mentally, emotionally, or spiritually. Remember, Aristotle profoundly said if you listen to the wrong kind of music, you will become the wrong kind of person.

If you would like to learn more information about the Illuminati and elite secret societies and conspiracies, I encourage you to read my other books on the subject, including *The Illuminati: Facts & Fiction, The New World Order: Facts & Fiction, The Resistance Manifesto*, or *Big Brother: The Orwellian Nightmare Come True.* My previous book, *The Illuminati: Facts & Fiction* contains a comprehensive analysis of the pieces of the Illuminati puzzle and thoroughly separates the facts from the fiction, and it will save you countless hours of Internet searching, following false leads, being duped by misinformation, hoaxes, or misunderstandings which are rampant in the sea of information that's out there.

[374] *Psychology Today* "The Halo Effect in Overdrive" by Kayla Causey and Aaron Goetz in *A Natural History of the Modern Mind* (July 1st 2009)

My books may not be available in stores, but they are available in paperback on Amazon.com or in e-book from iBooks on the iPad, Google Play for Android tablet users, as well as Kindle and Nook e-readers. Please review this book on Amazon.com or whatever platform you purchased it from to help spread the word about these Illuminati icons of evil and the other important and empowering information my books reveal. Thank you for reading, thank you for caring, and may God bless you in this magnificent and monumental mystery we call life!

Also by Mark Dice:

-The Illuminati: Facts & Fiction
-The New World Order: Facts & Fiction
-The Resistance Manifesto
-Big Brother: The Orwellian Nightmare
Come True

Also by Mark Dice:

-The Illuminati: Facts & Fiction
-The New World Order: Facts & Fiction
-The Resistance Manifesto
-Big Brother: The Orwellian Nightmare
 Come True

Connect with Mark on:

Facebook.com/MarkDice
Twitter.com/MarkDice.com
YouTube.com/MarkDice
MarkDice.com

Connect with Mark on:

Facebook.com/MarkDice
Twitter.com/MarkDice.com
YouTube.com/MarkDice
MarkDice.com

Printed in Great Britain
by Amazon

47569698R00136